Wunderlust

The Photos of a Traveling Muse

Photos by Michael Thaxton

All Photos Owned and Copyrighted by

Michael Thaxton Photography

Wunderlust – a strong desire to travel.

I have been traveling since I was 17 and joined the Navy. Today, I can say there is a lot of travelling left to do in my life. I am satisfied with the journeys I have taken so far.

This book is a snapshot of just a few years of being in Upstate New York and St. Louis, Missouri. I had to sort through thousands of photos to choose these fifty.

I would like to thank a few people for encouraging me and helping get this book completed:

George Mills – the basic skills you taught me in High School helped create the images in this book.

My Mother – Barbara Strozyk Gravelle – Love you, you have always been an encouragement to me. I had to release this book on your 70th birthday to pay tribute to you for giving me my first camera.

Pastor Tamara Franchuk – words can't thank you enough for the encouraging words and prayers.

My children and grandchildren – you guys are the driving force behind all this creativity.

And last – **Sheree (S. Coop)** – I love you, you have pushed me to the limits and this book would not be possible without you.

To see more of my photograhy check out my facebook page

www.facebook.com/michaelthaxtonphotos

All these prints are available for sale, feel free to contact me at mthaxton@gmail.com.

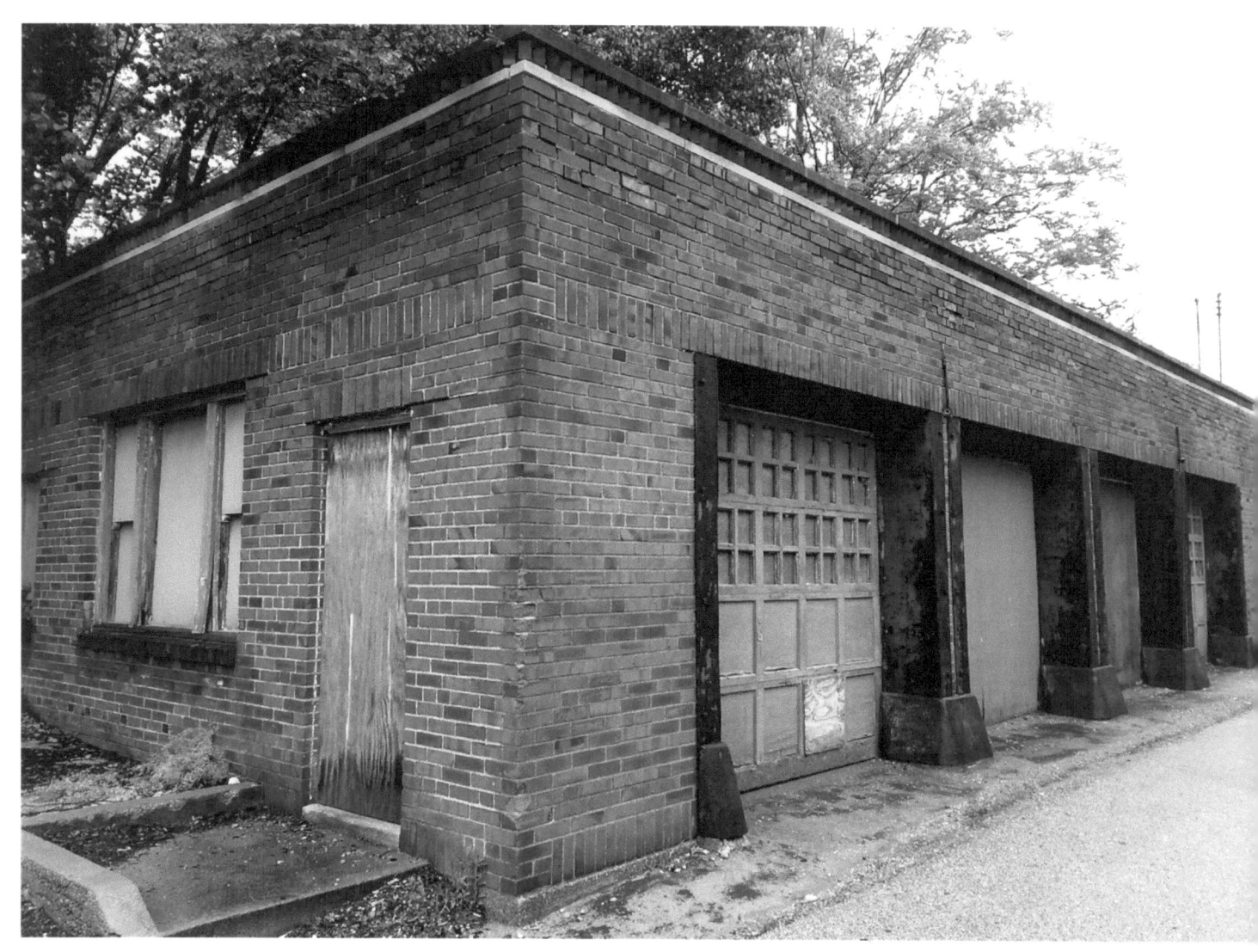

The Garage
St Louis, Mo
Spring 2016

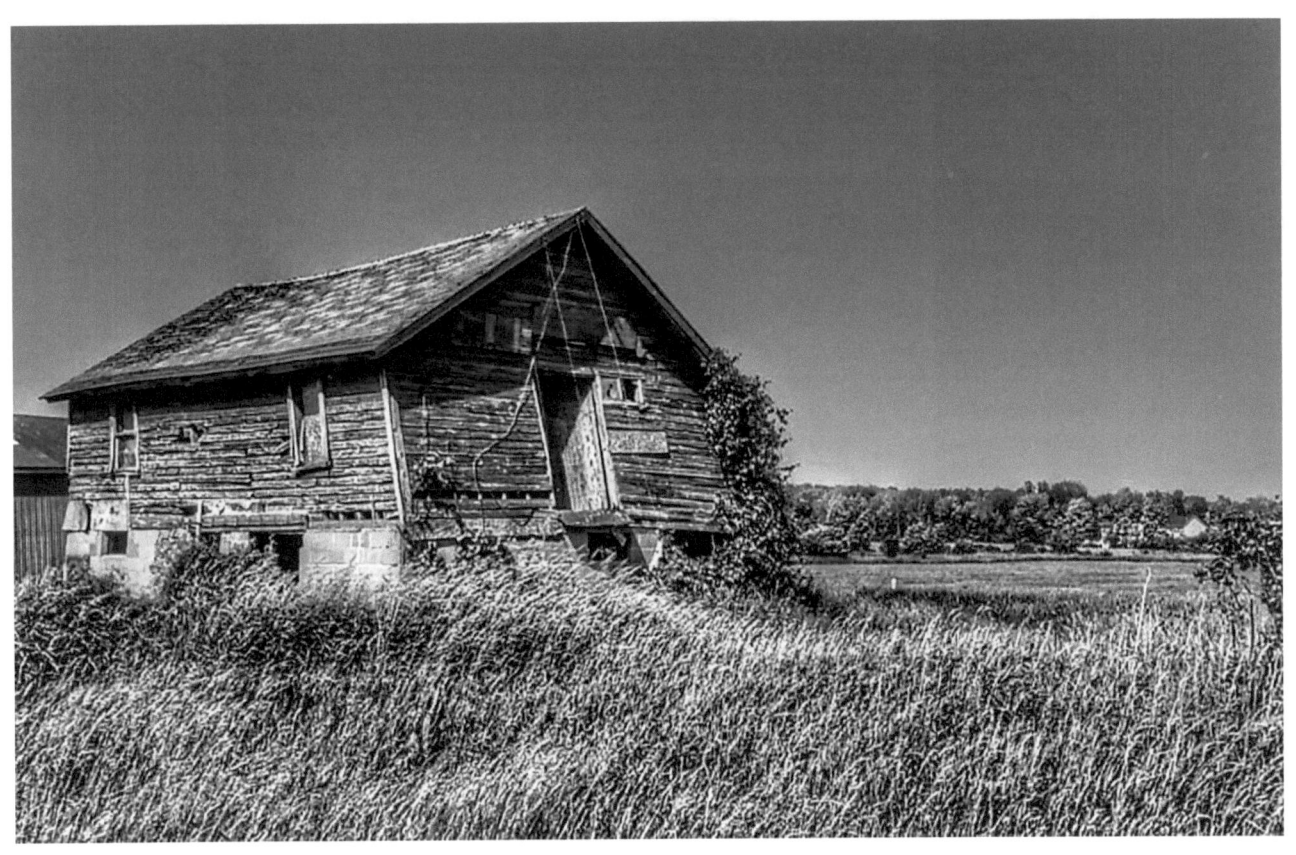

Abandoned House
Churchville, NY
Summer 2016

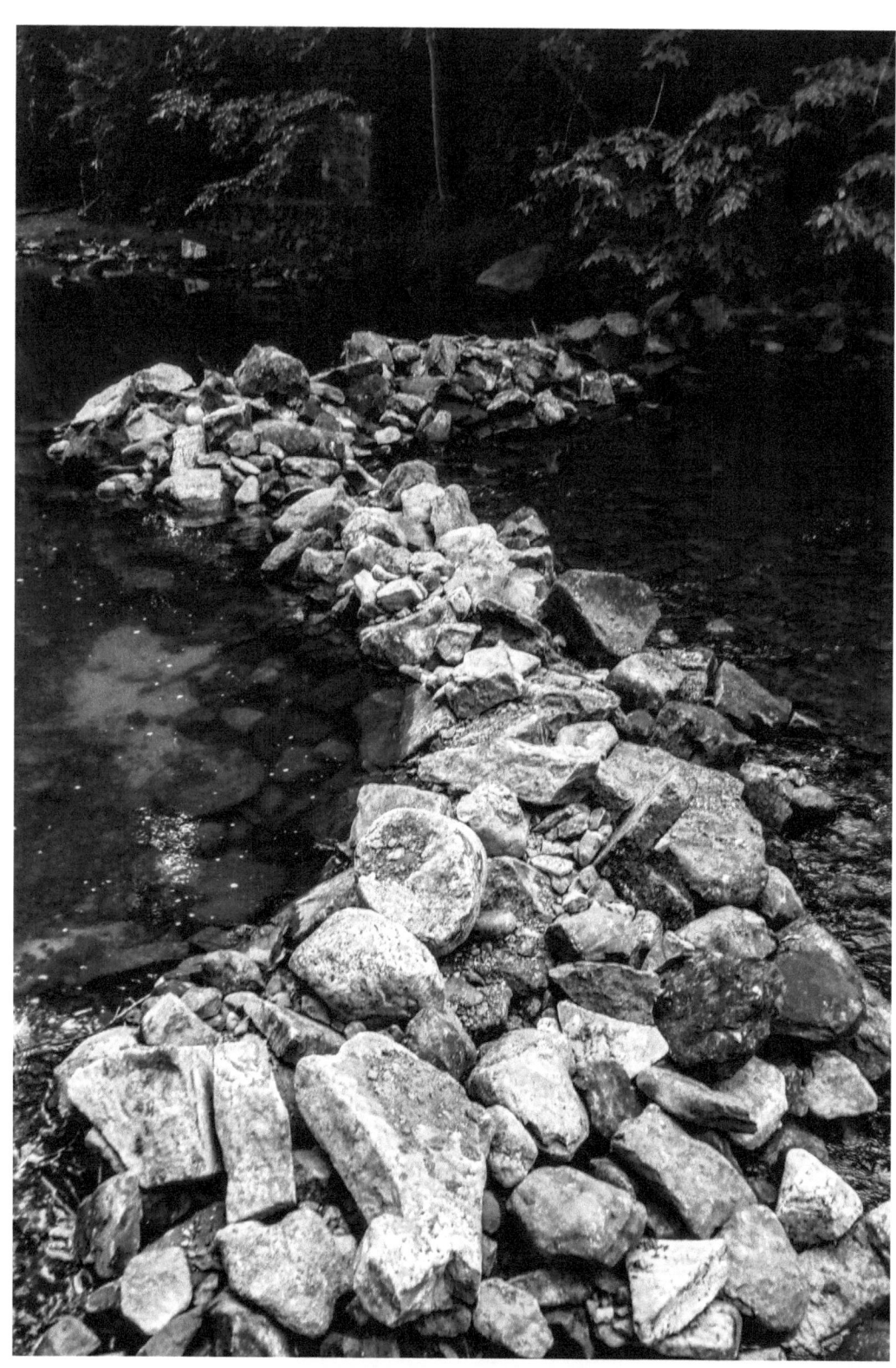

Rock Dam

Corbett's Glenn, Penfield, NY
Summer 2016

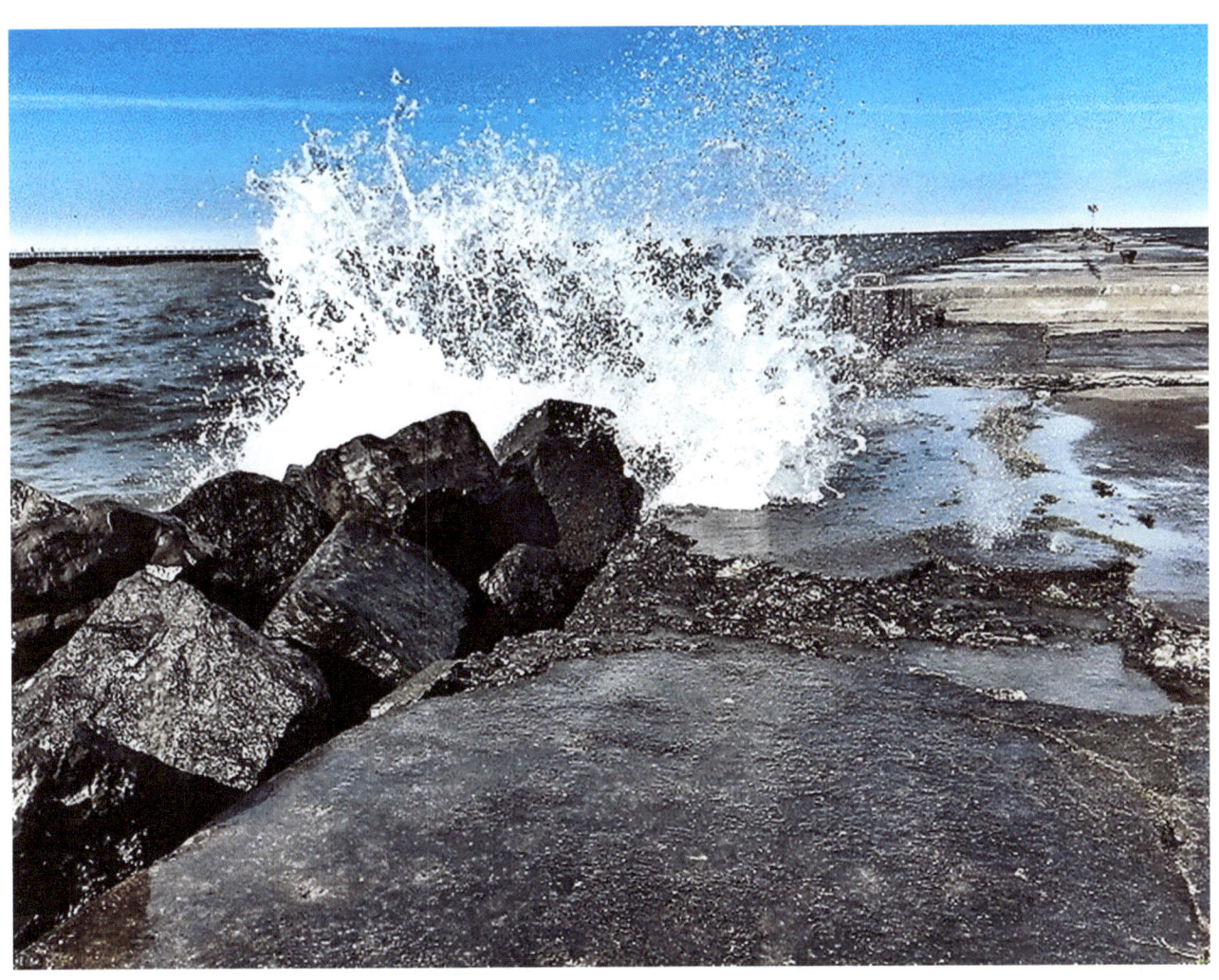

Wave Crash
Summerville Pier, Rochester, NY
Summer 2016

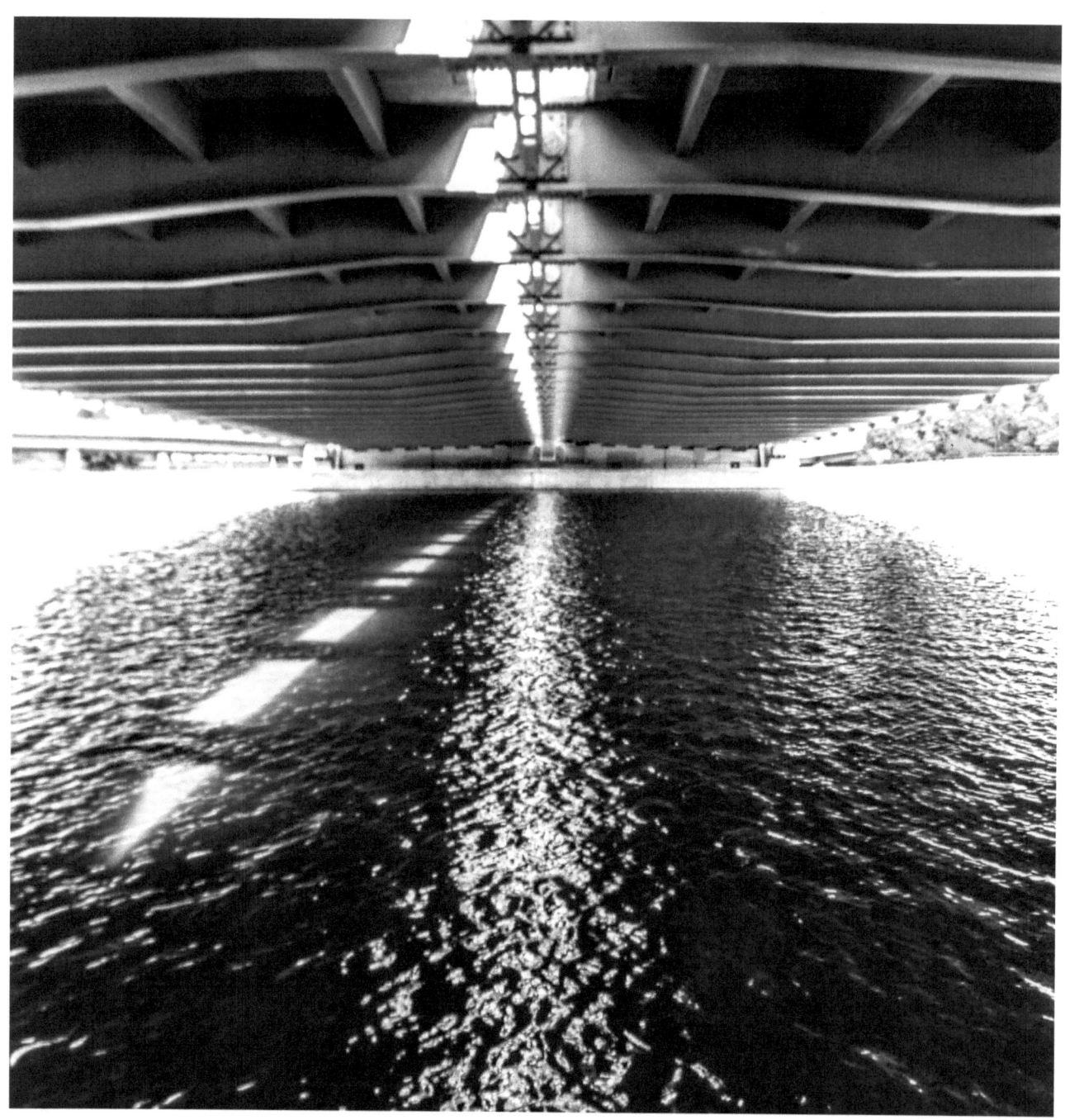

Water Under The Bridge
Rochester, NY
Summer 2016

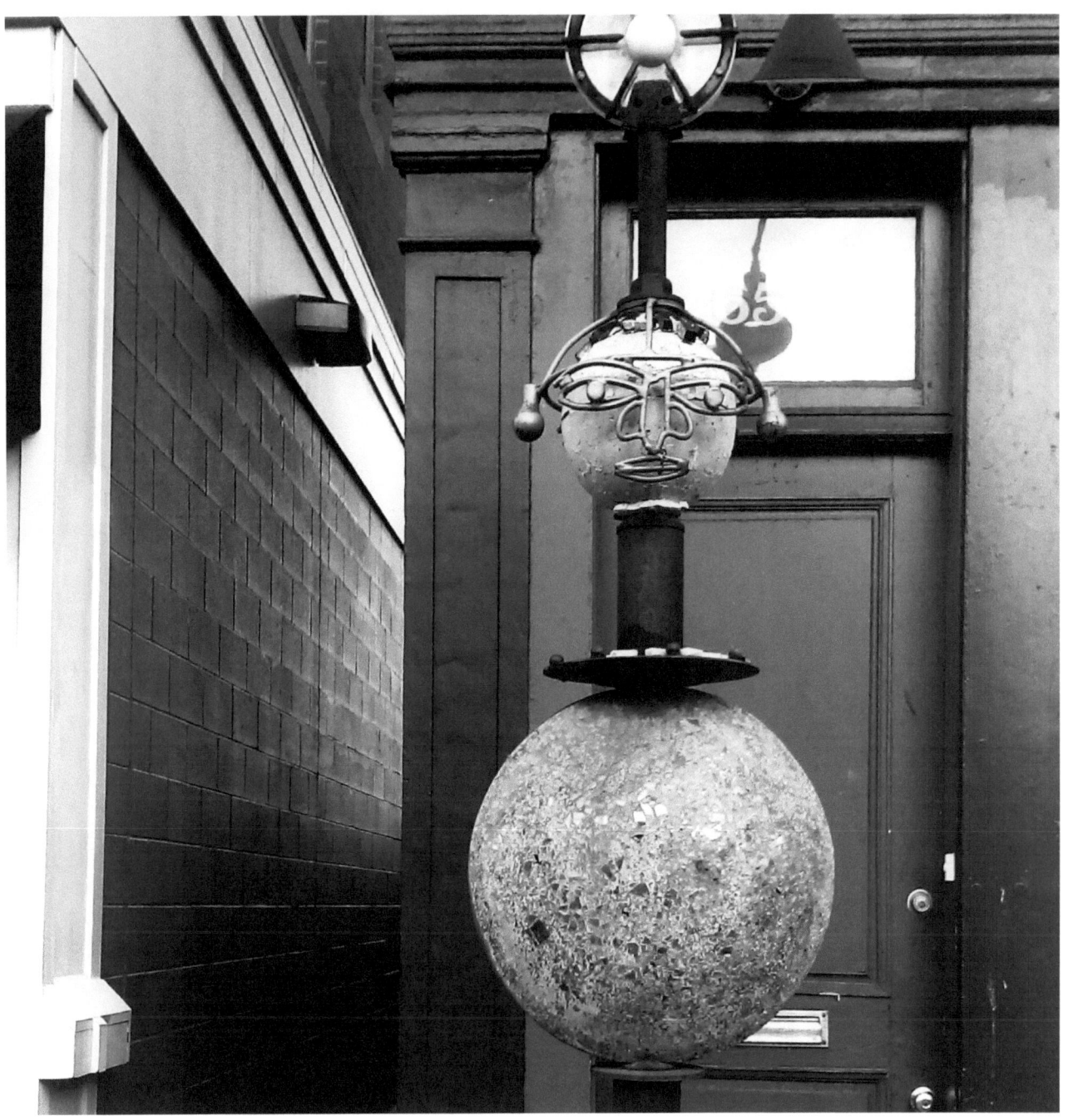

South Wedge
Rochester, NY
Summer 2016

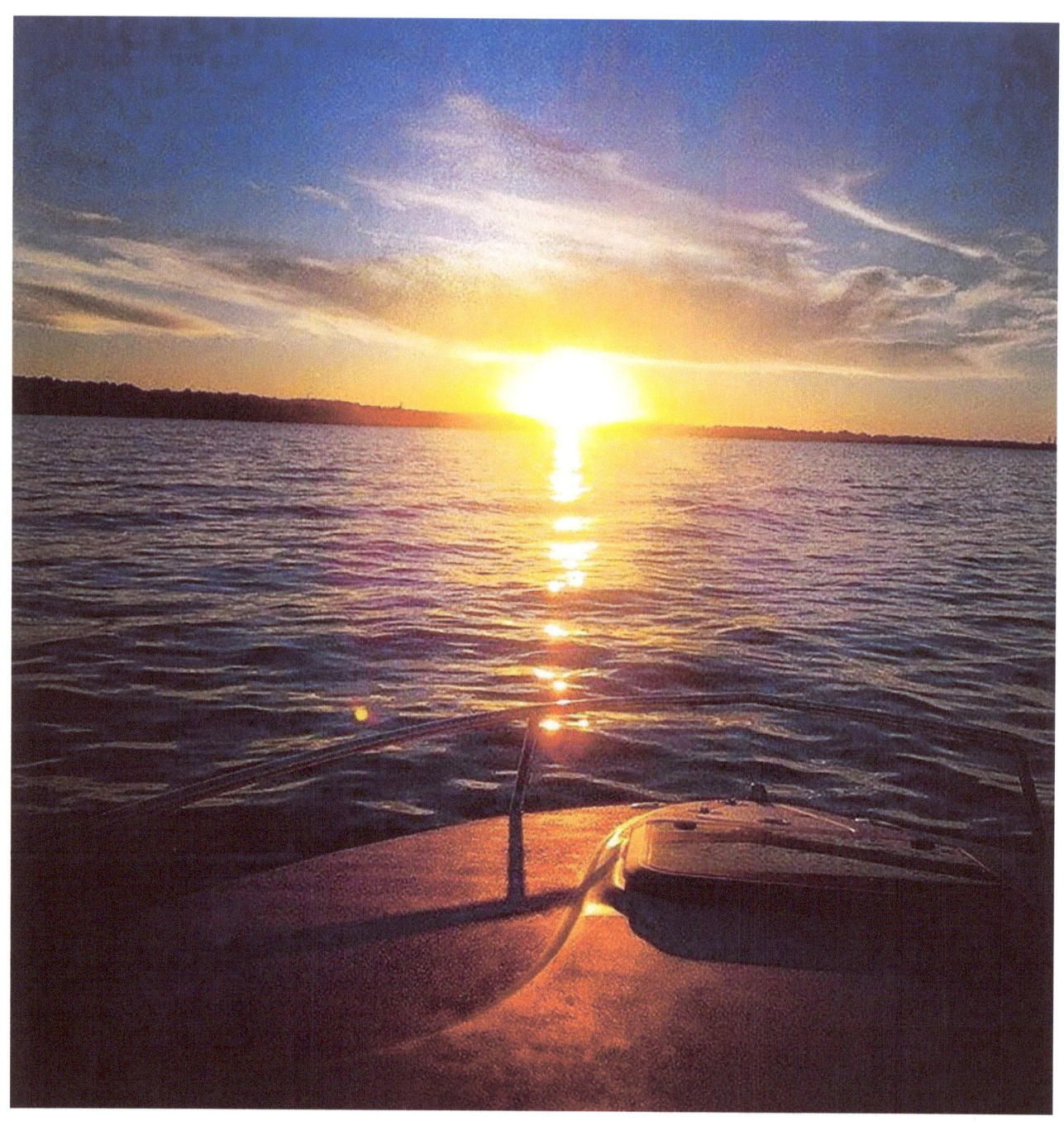

Sunset on Lake Ontario

Summer 2014

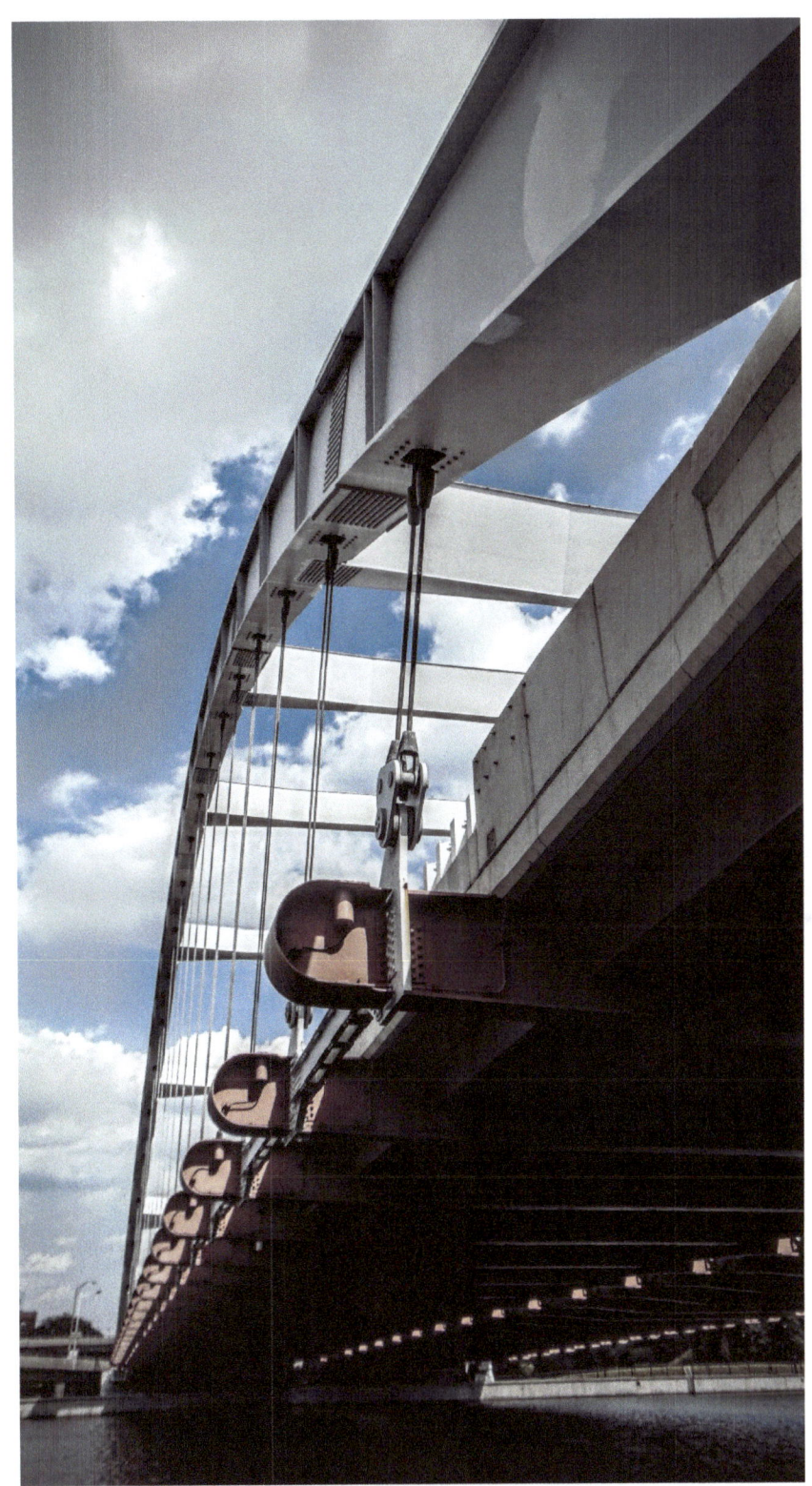

The Bridge
Rochester, NY
Summer 2016

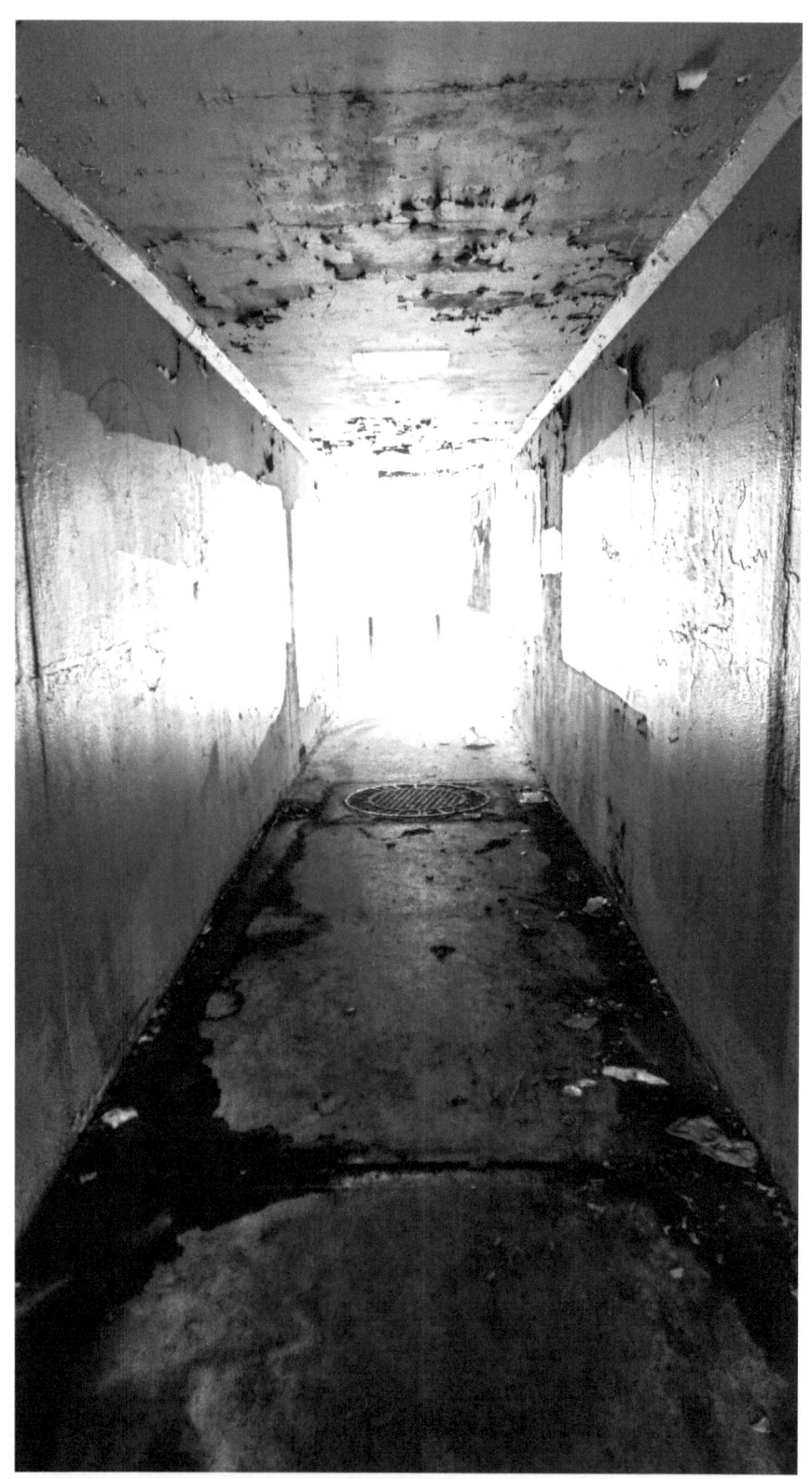

Light At The End Of The Tunnel
Rochester, NY
Summer 2016

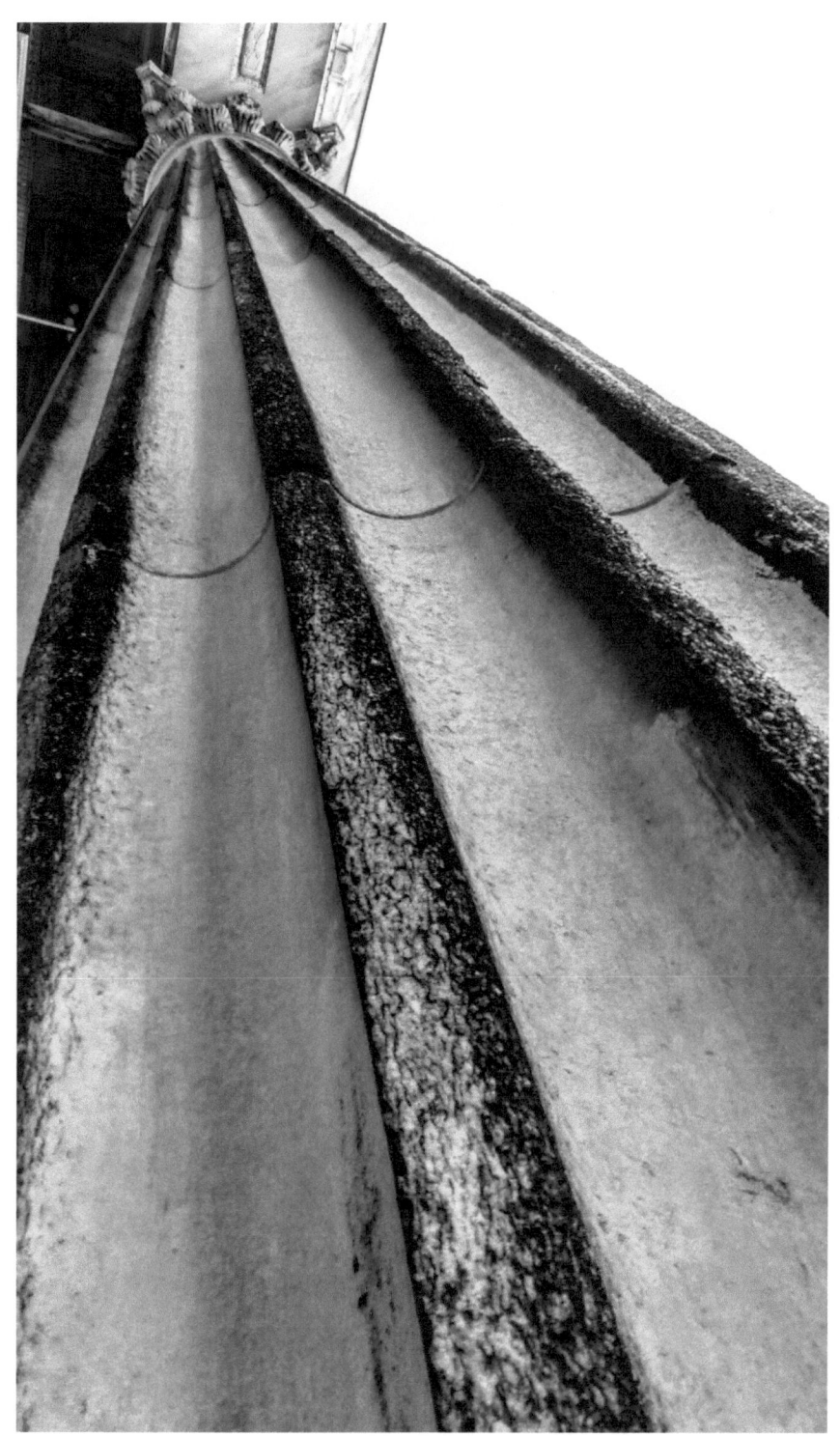

The Column
Rochester, NY
Summer 2016

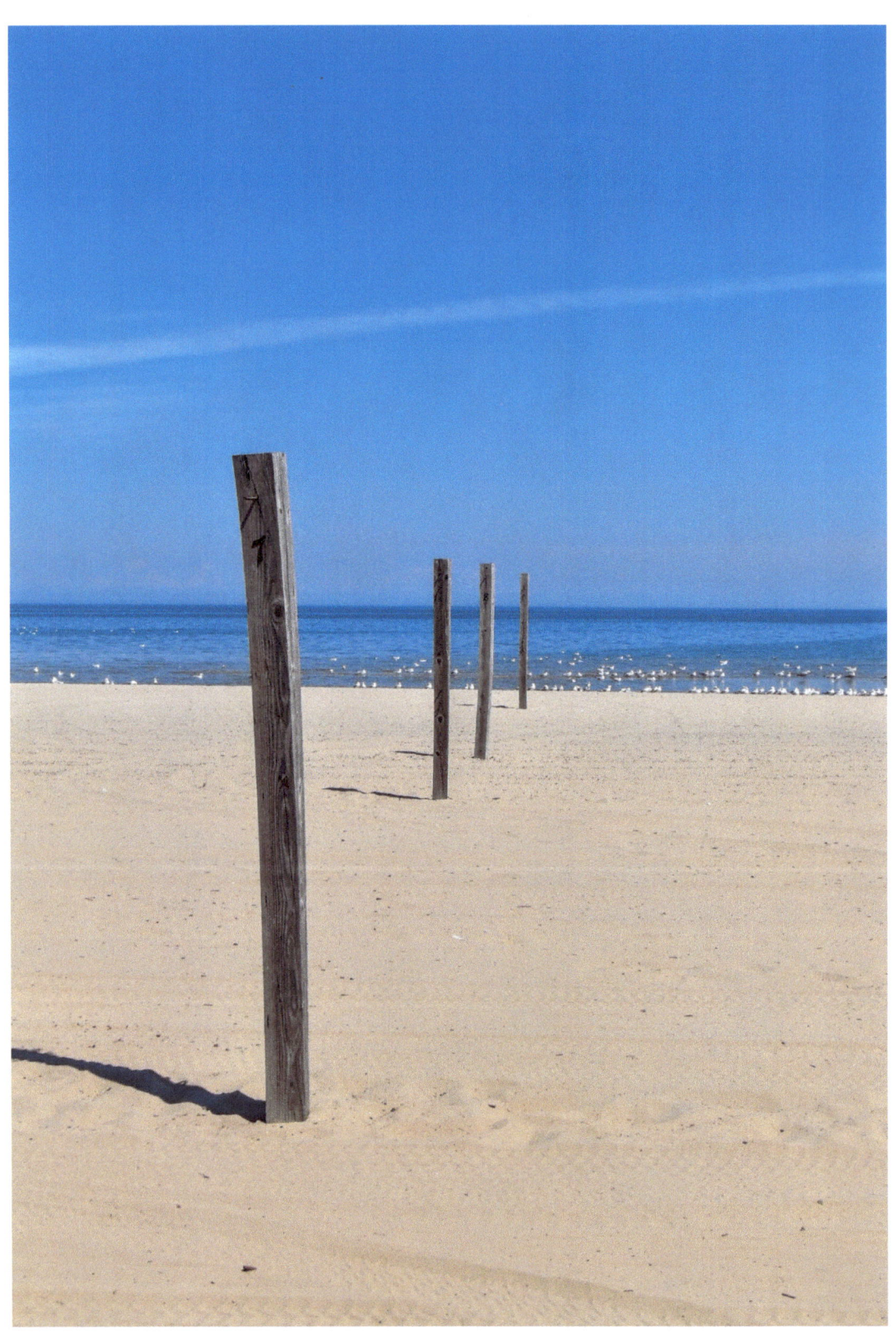

Volleyball Courts
Charlotte Beach, Rochester, NY
Summer 2016

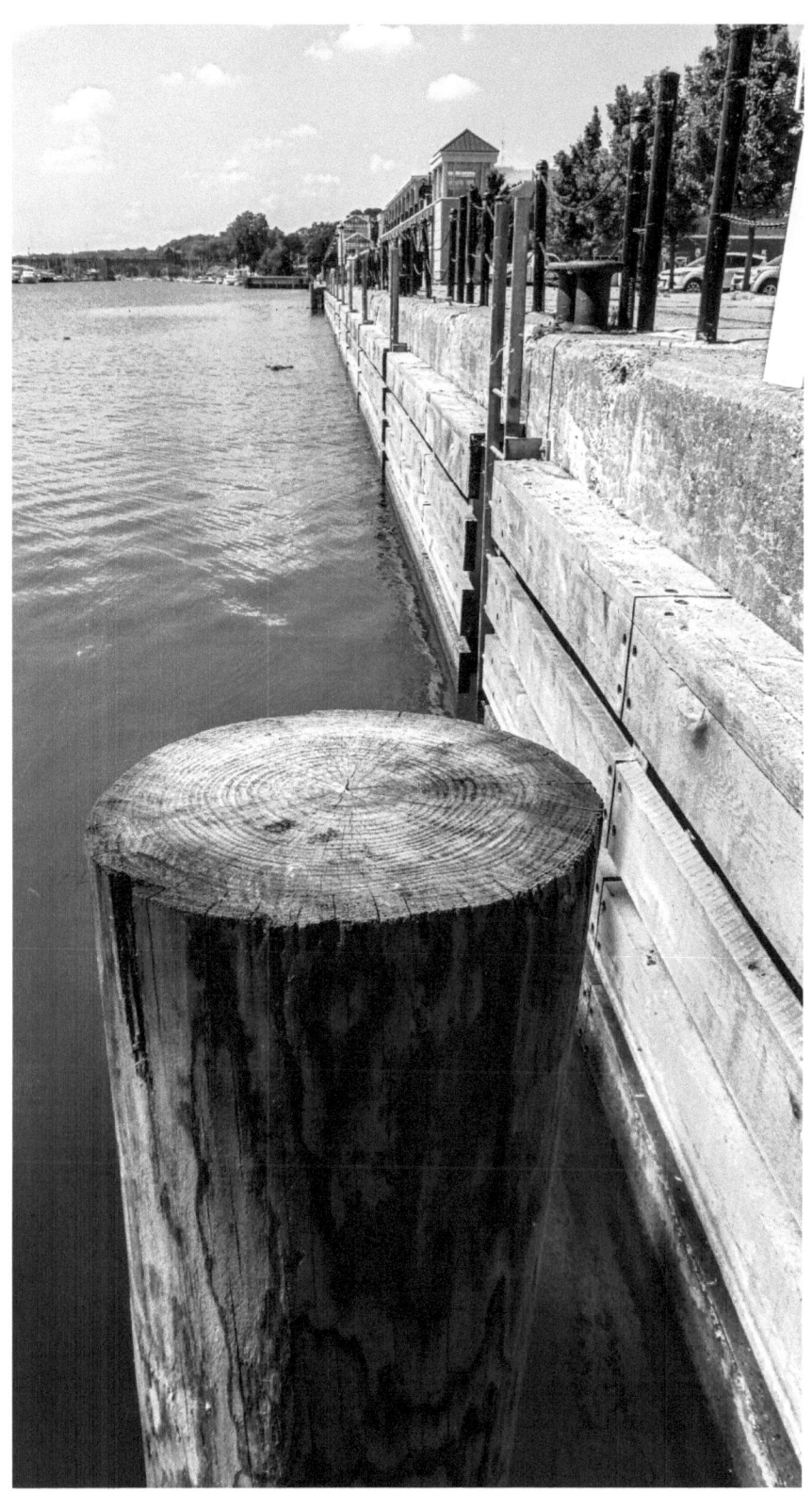

Port of Rochester

Rochester, NY
Summer 2016

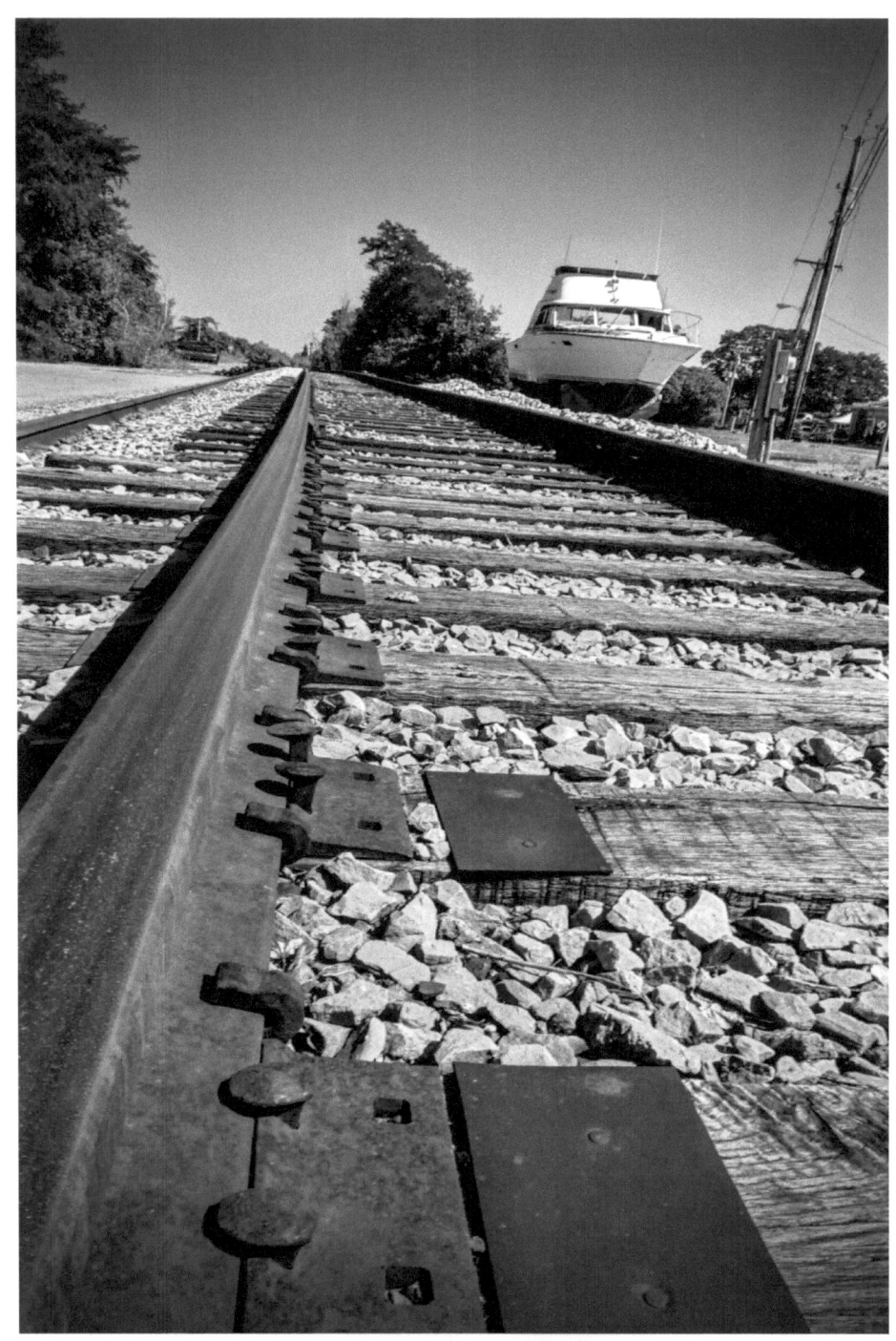

Landlocked
Rochester, NY
Summer 2016

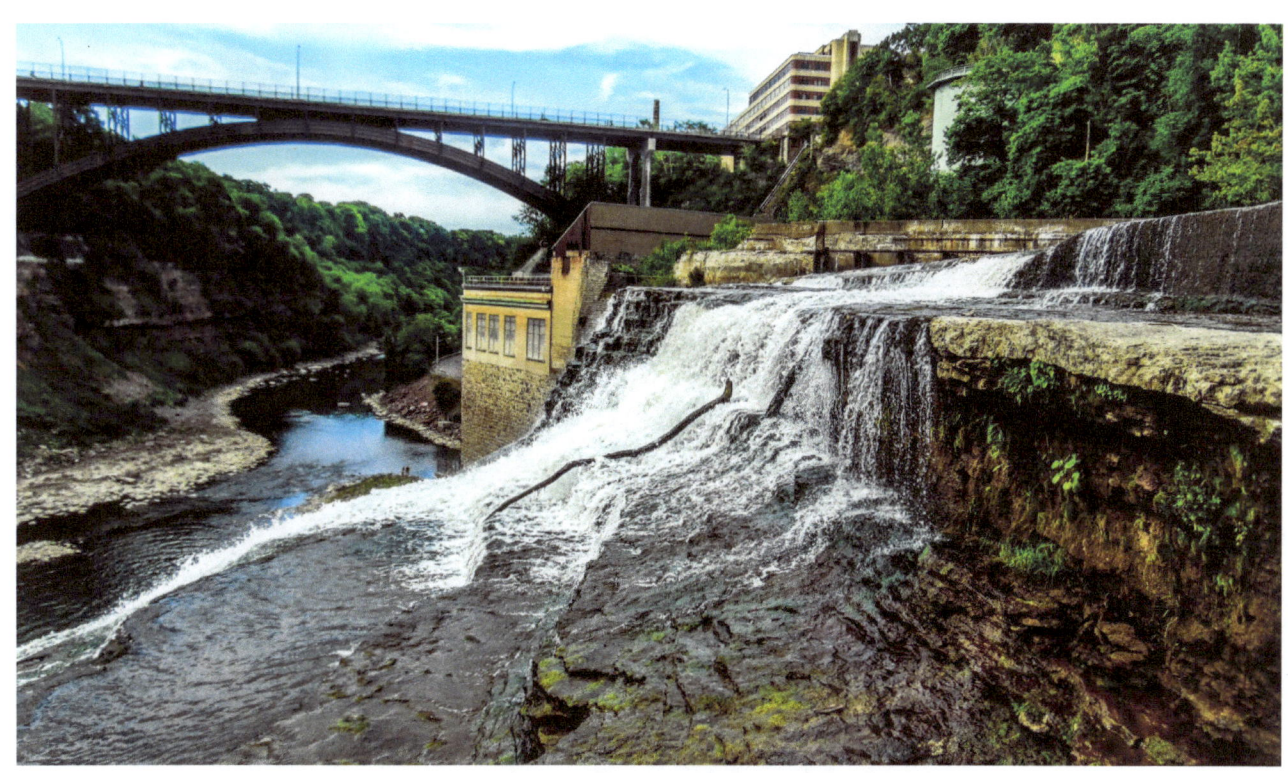

Middle Falls
Genesee River
Rochester, NY
Summer 2016

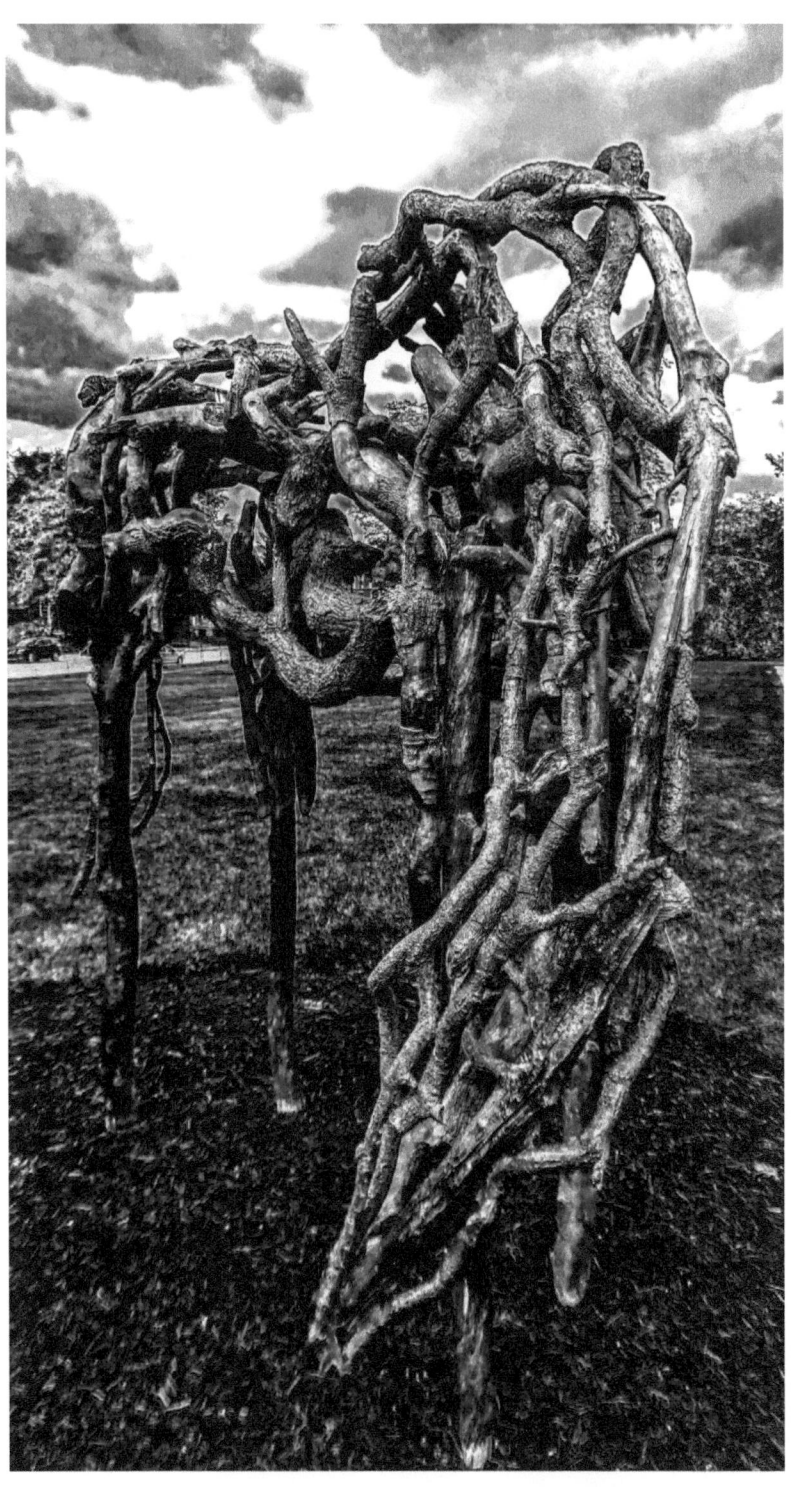

Dry Bones

Memorial Art Gallery
Rochester, NY
Summer 2016

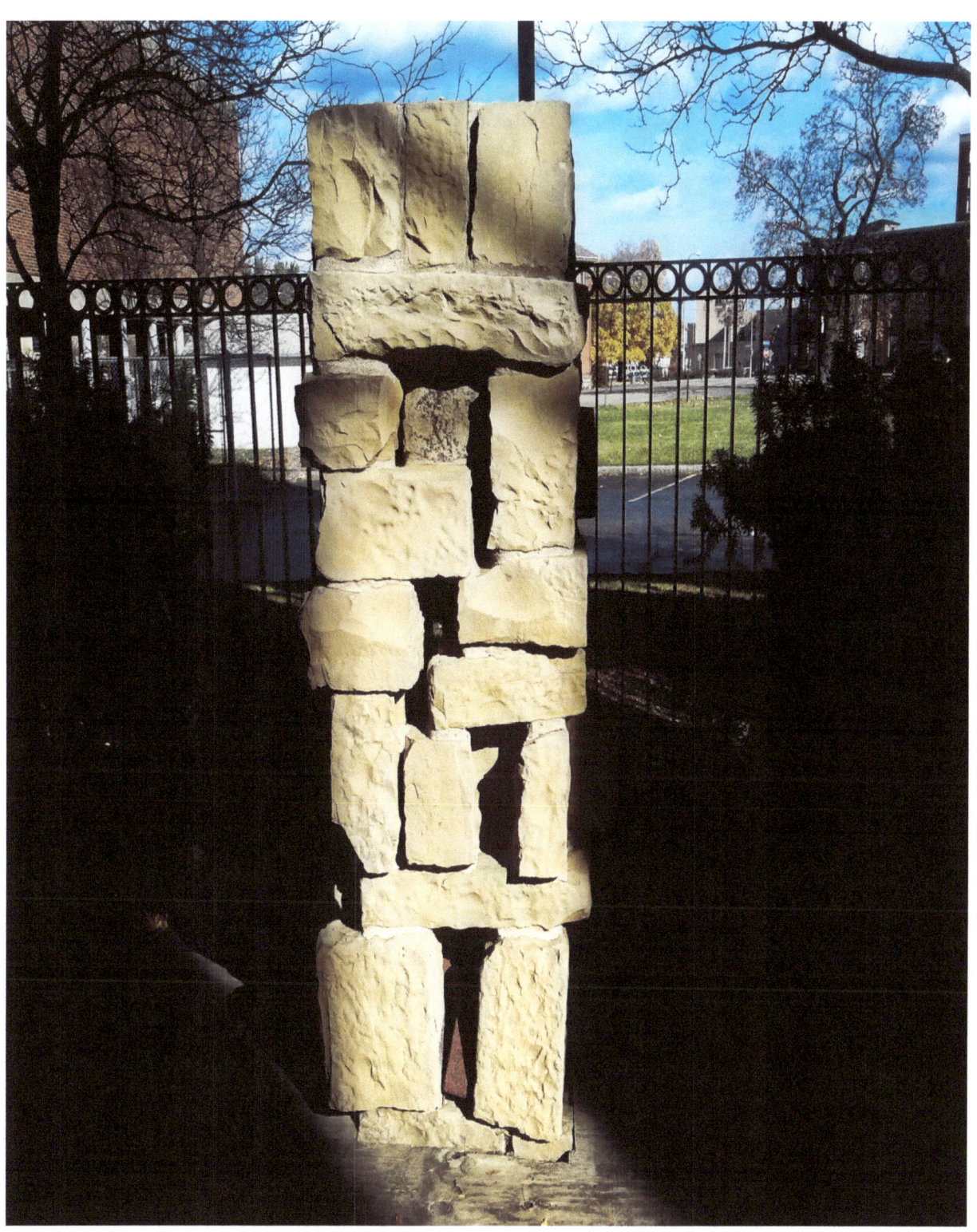

Sunlight

St. Joseph's Park
Rochester, NY
Fall 2014

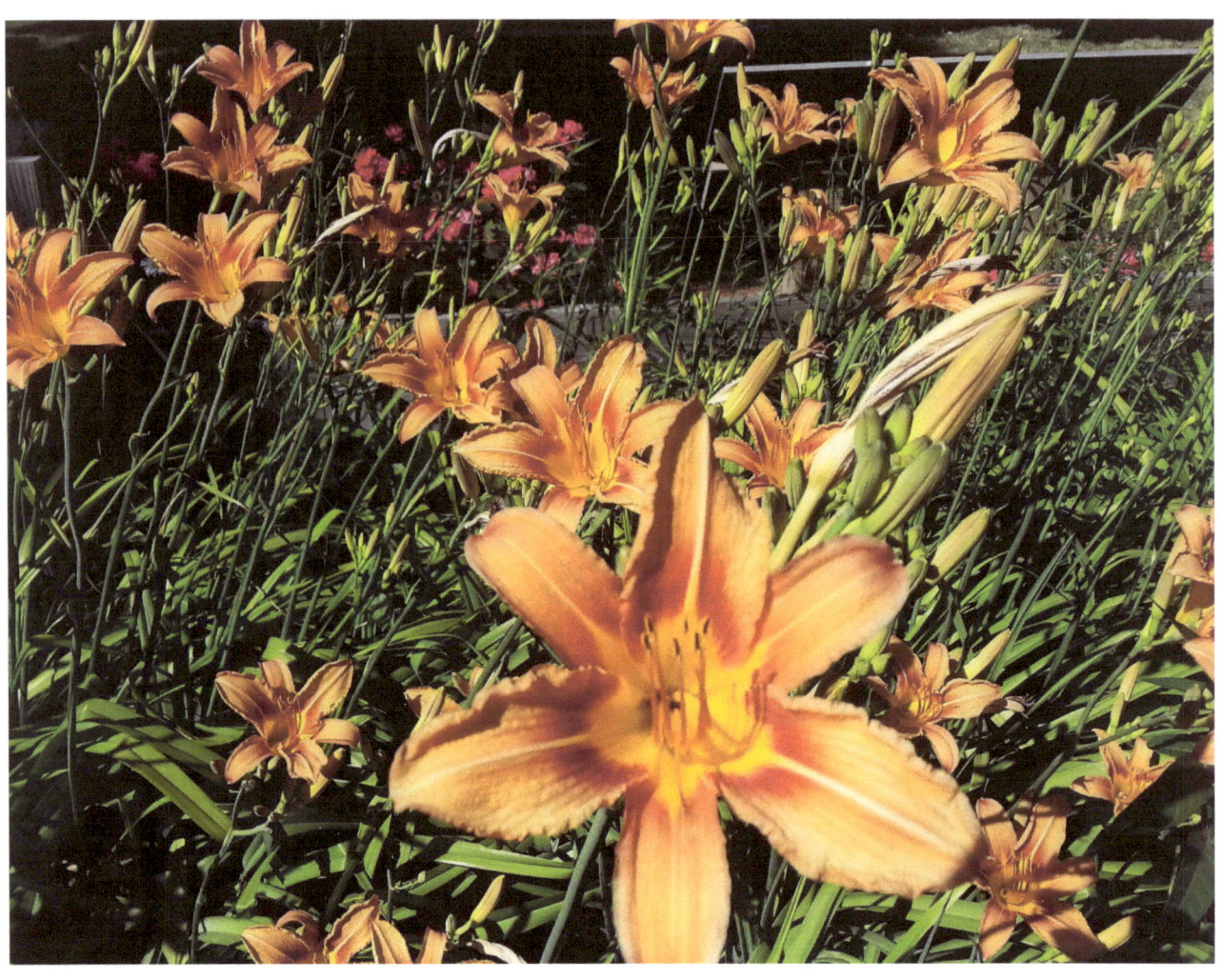

Flowers in Charlotte
Rochester, NY
Summer 2016

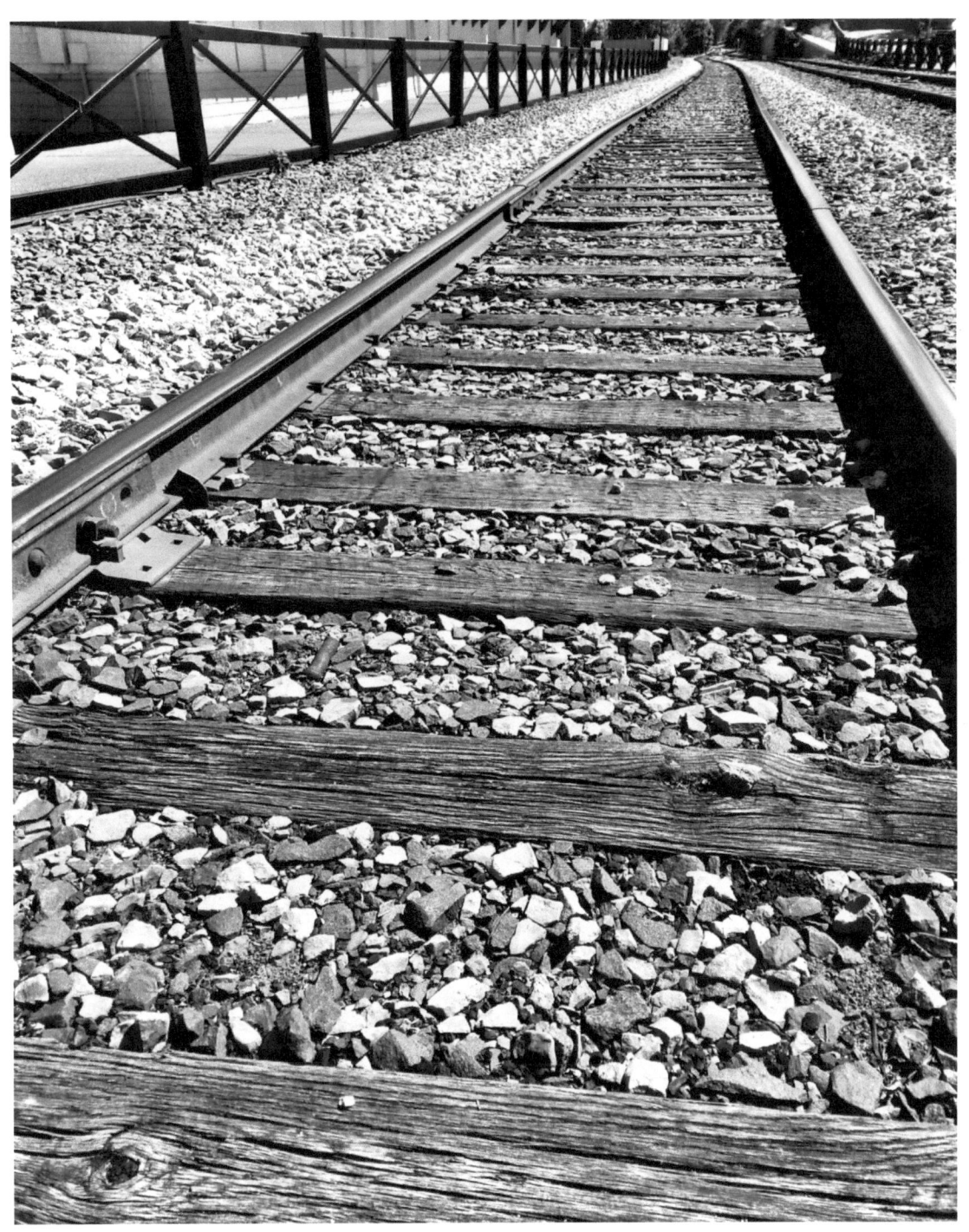

Open Tracks
Rochester, NY
Summer 2016

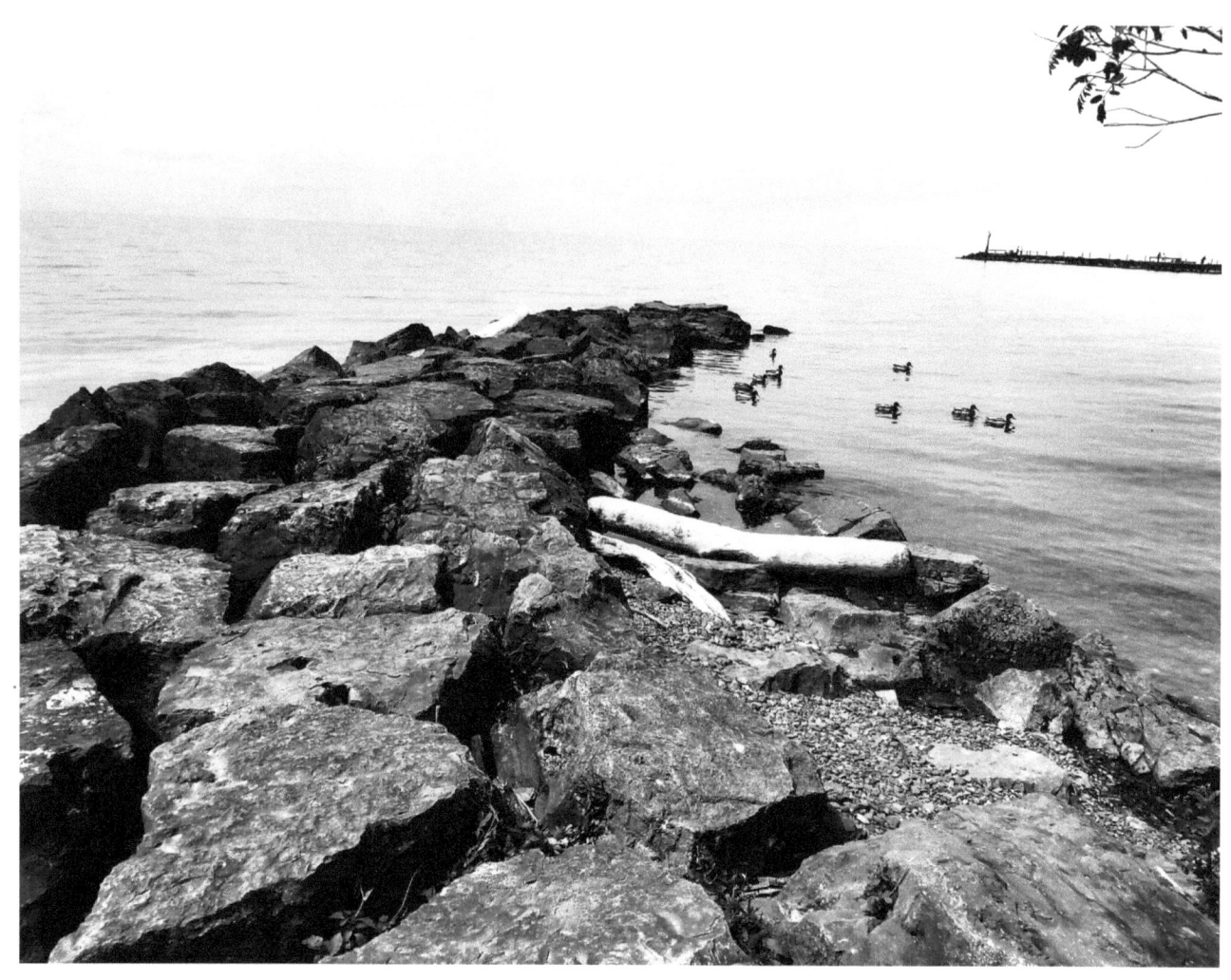

Webster Park

Webster, NY
Summer 2016

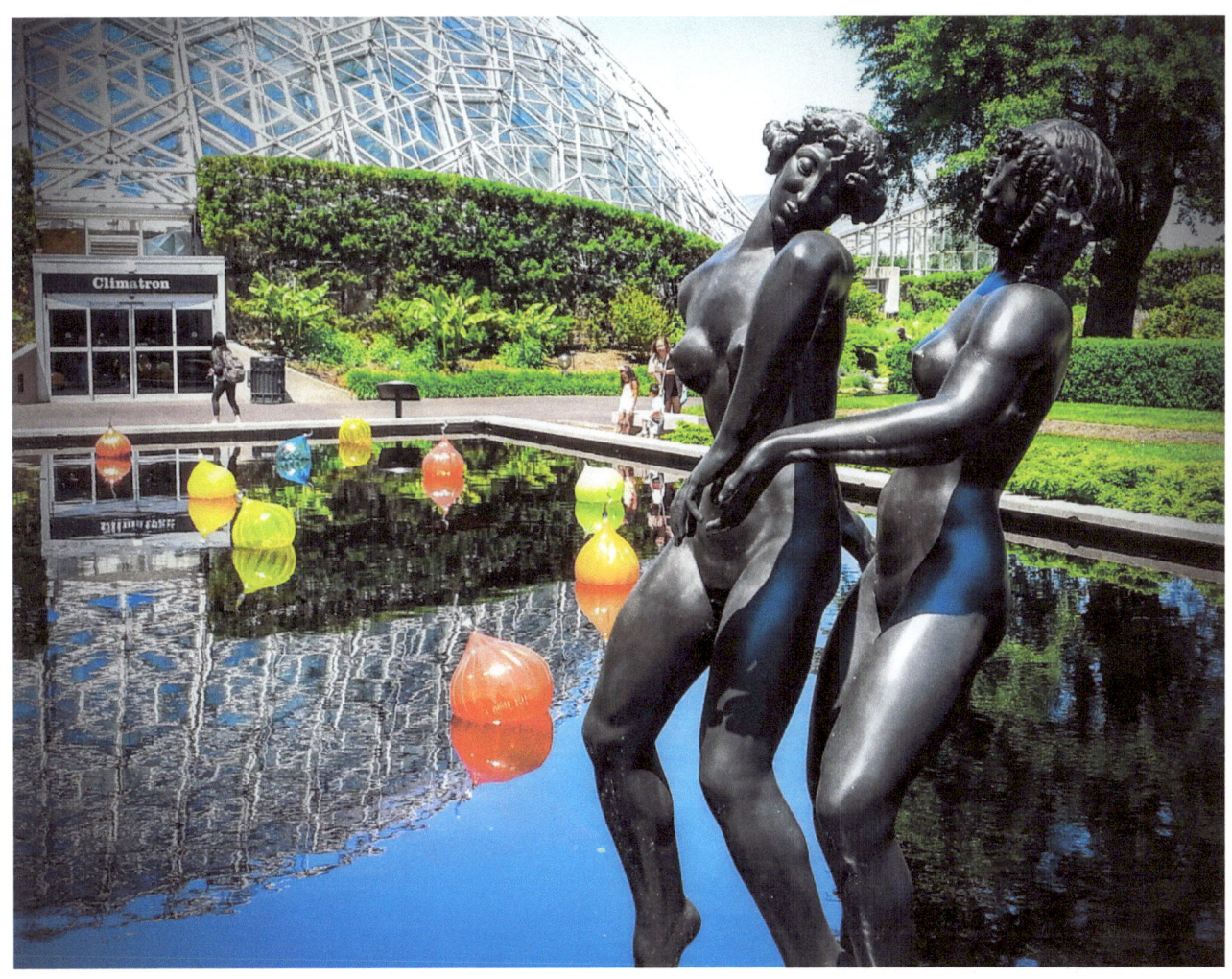

Reflection Pool
Missouri Botanical Gardens
St Louis, MO
Spring 2016

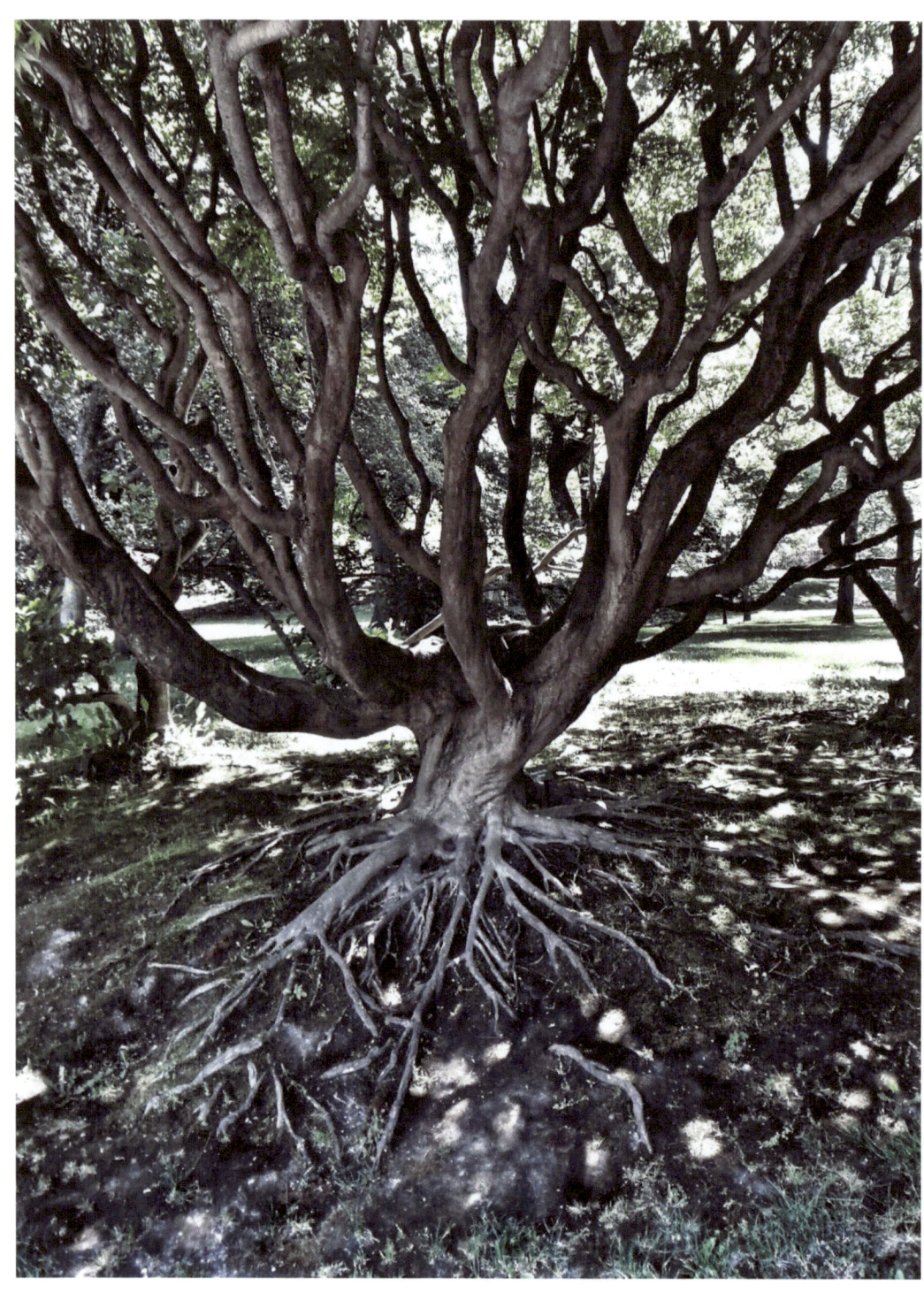

Tree of Life

Missouri Botanical Gardens
St Louis, MO
Spring 2016

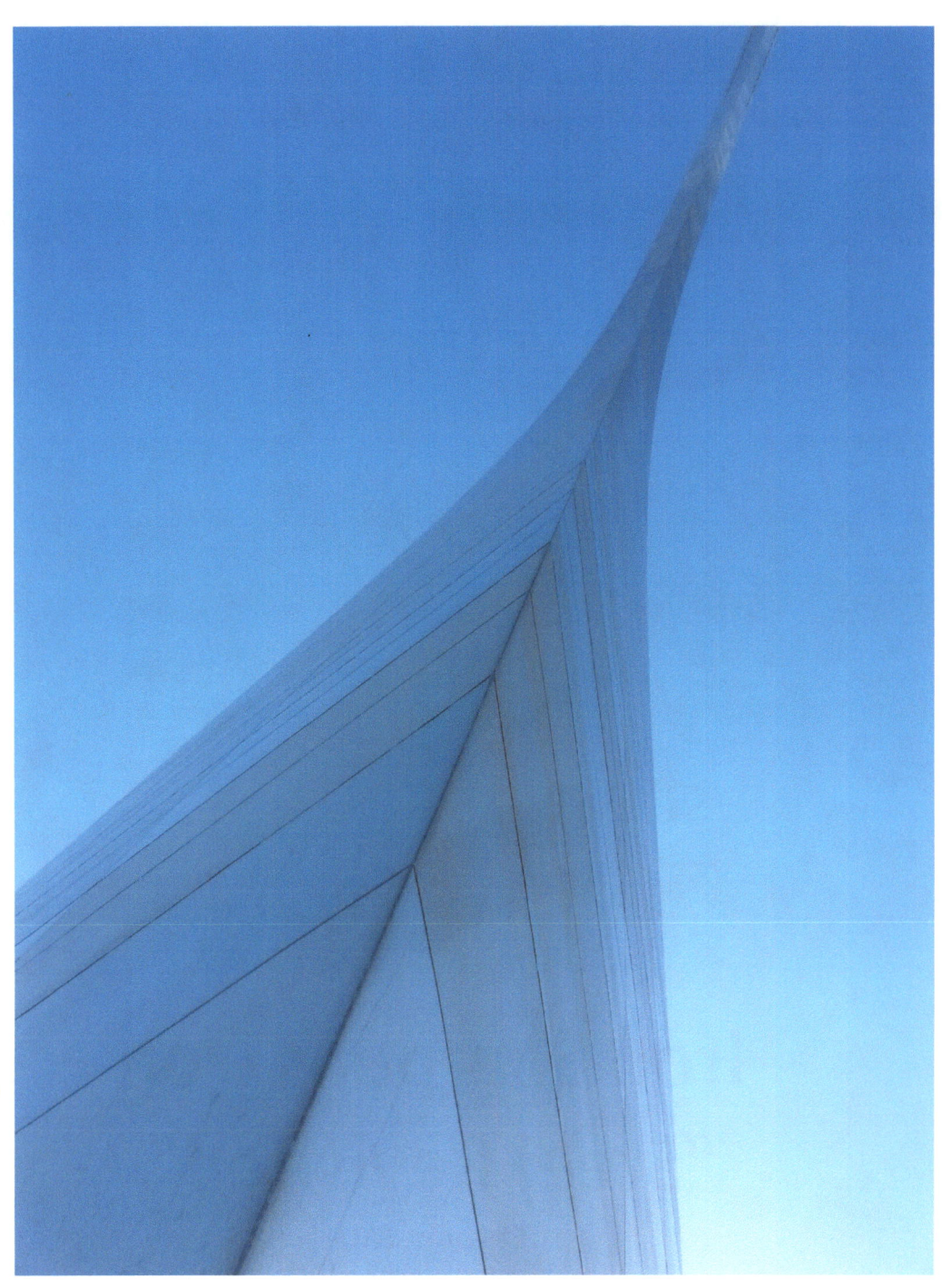

Gateway Arch
St Louis, MO
Spring 2016

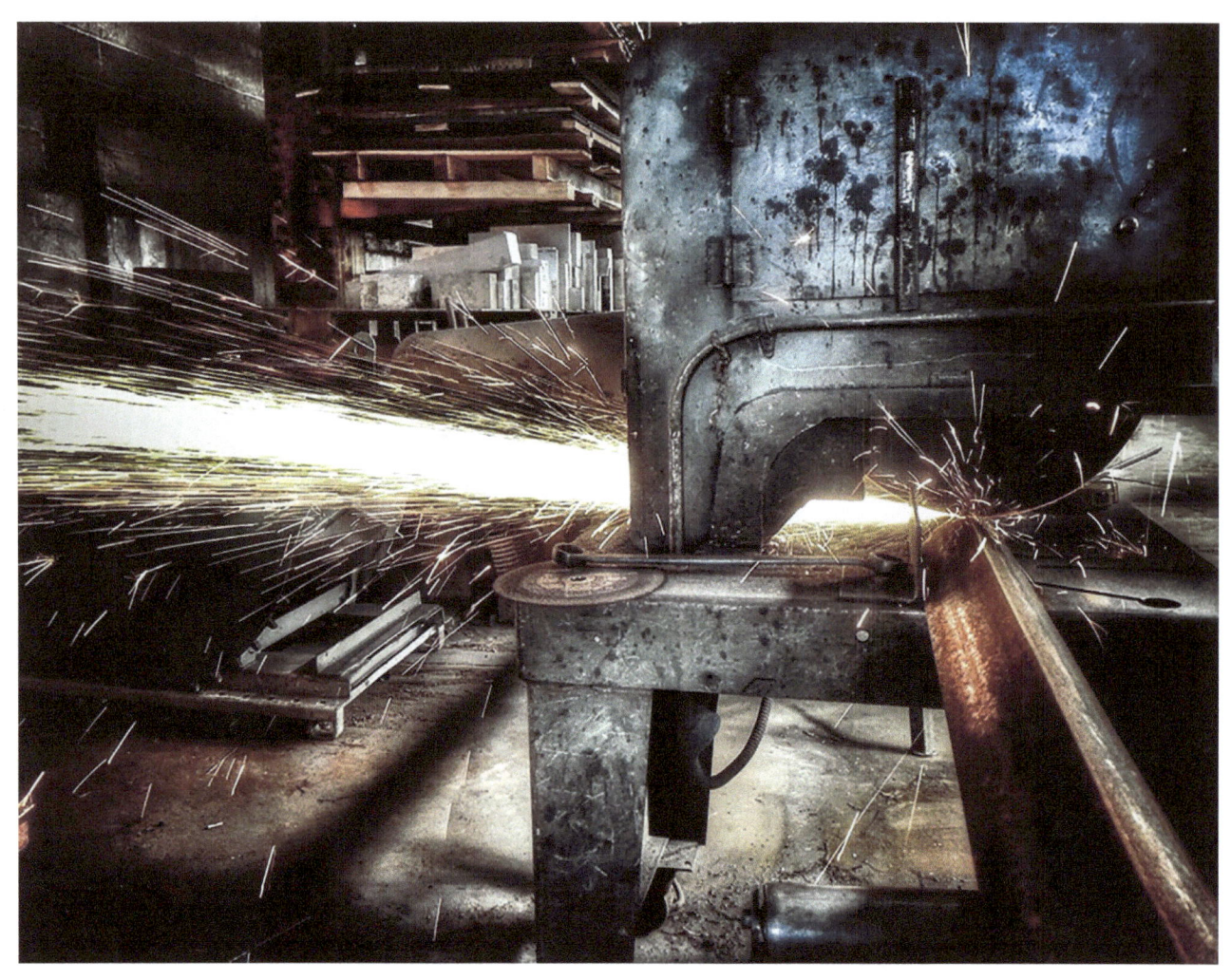

Iron Sharpens Iron
"Steel Revisited"
St Louis, MO
Spring 2016

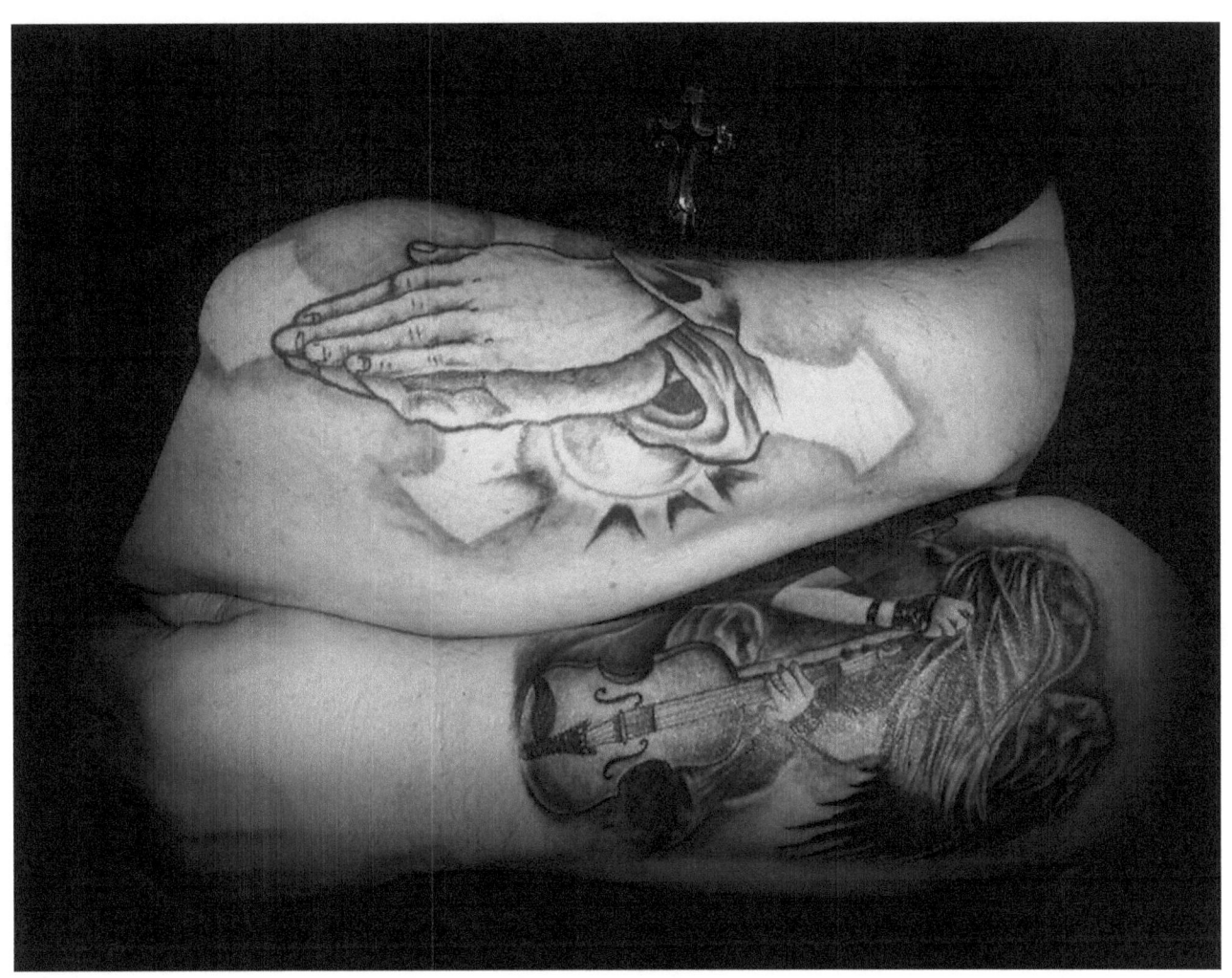

My Ink
Rochester, NY
Fall 2013

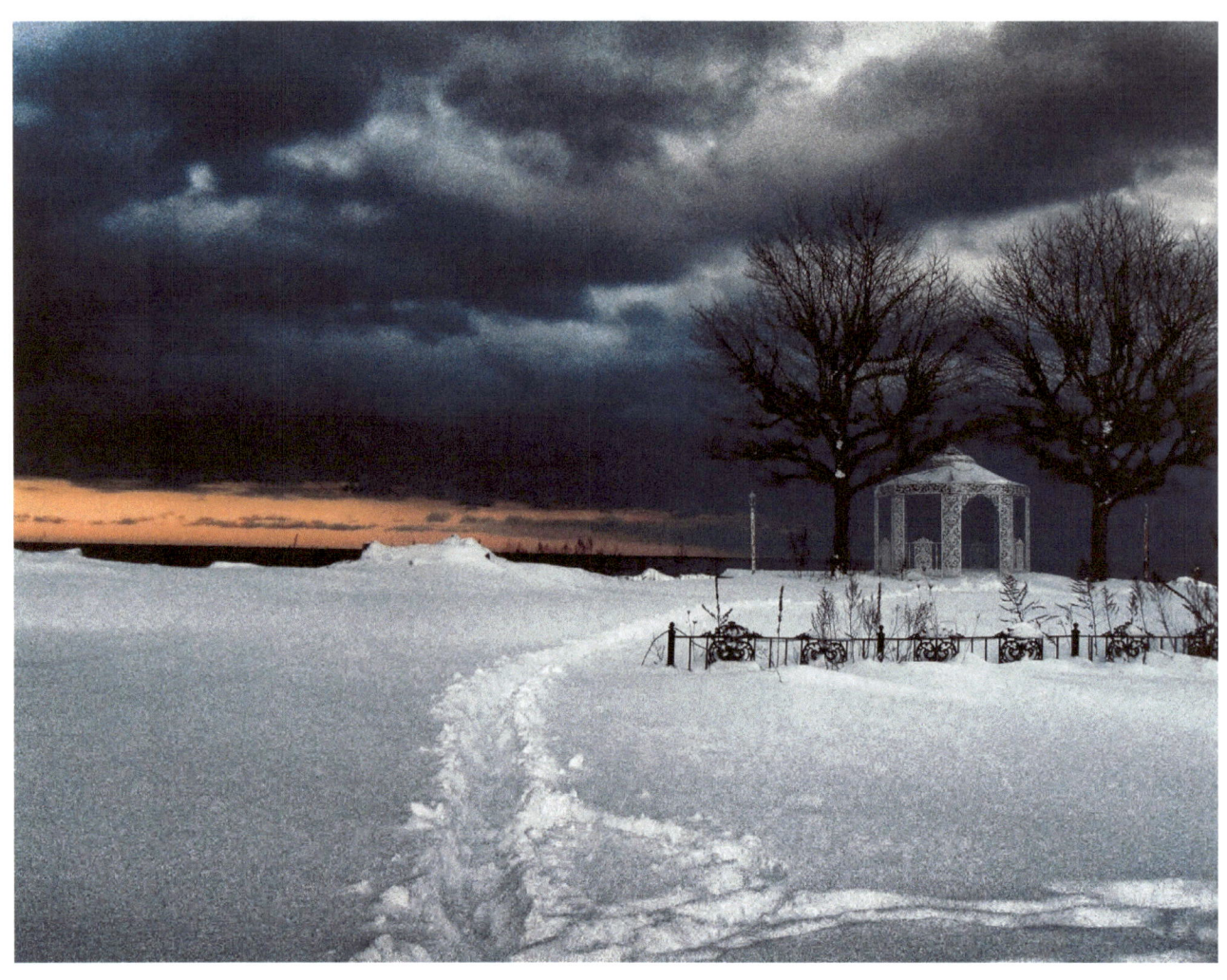

After the Storm
Crescent Beach Hotel
Greece, NY
Winter 2016

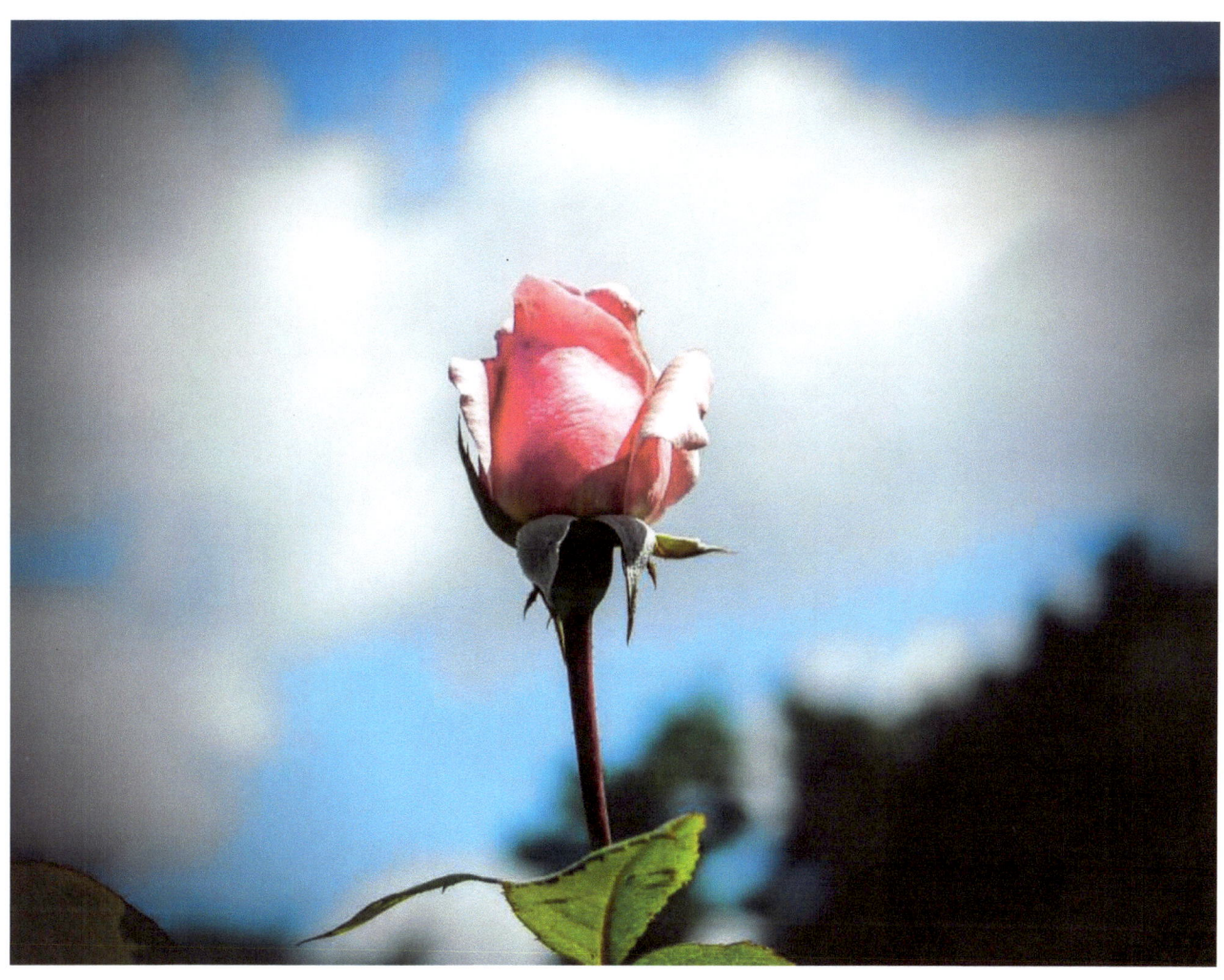

In The Morning
Maplewood Park and Rose Garden
Rochester, NY
Summer 2012

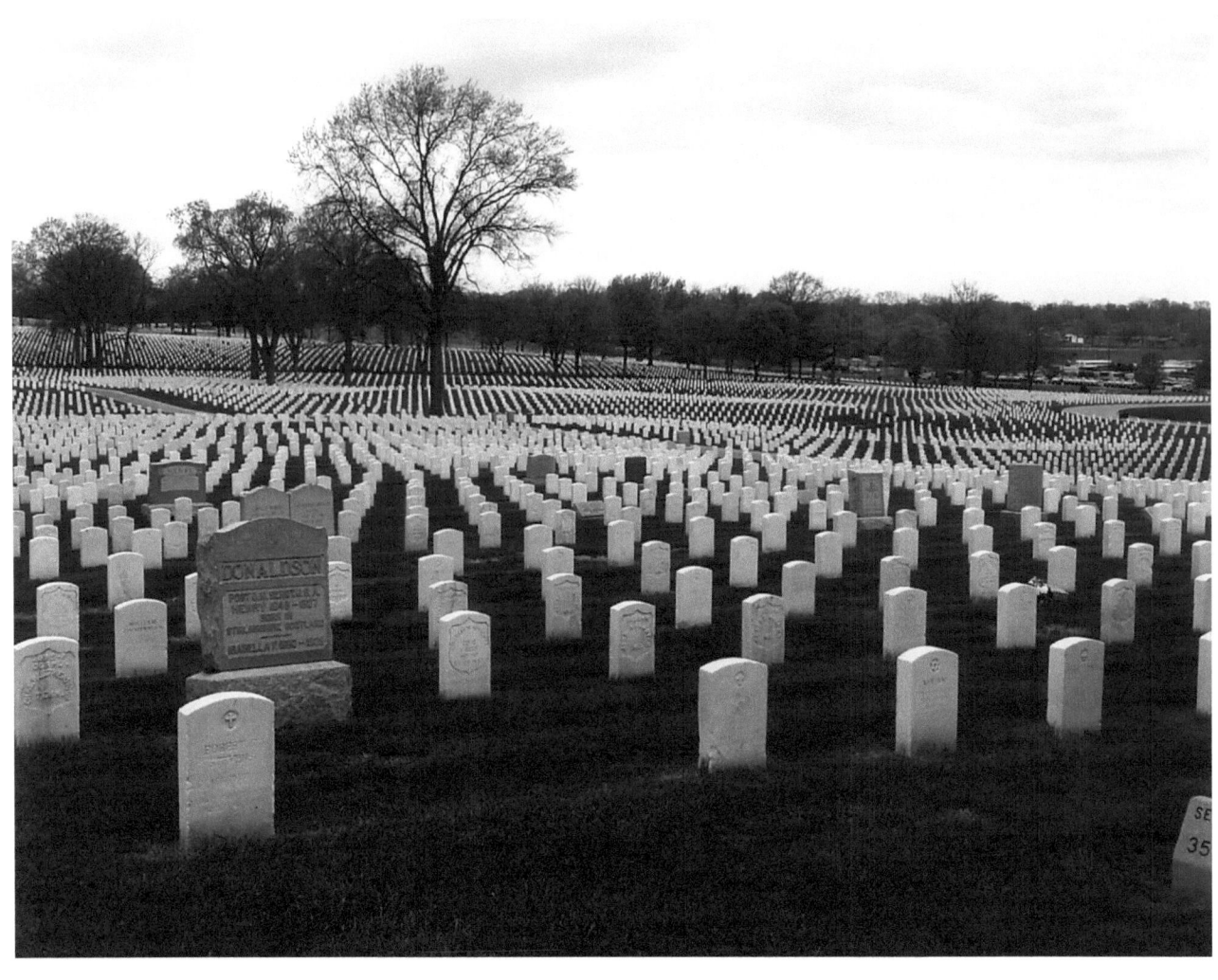

Heroes
Jefferson Barracks National Military Cemetery
St Louis, MO
Spring 2016

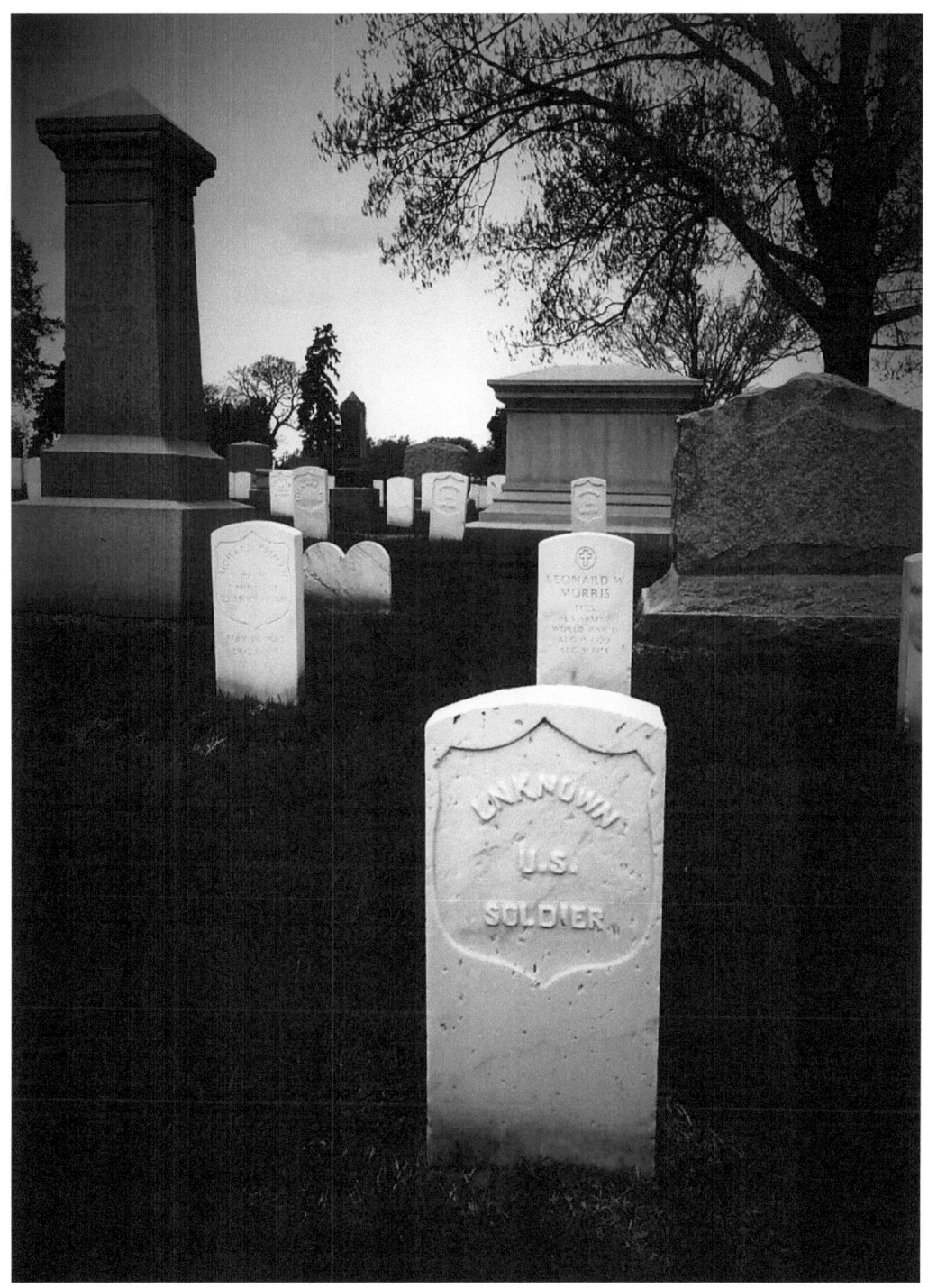

Unknown U.S. Soldier
Jefferson Barracks National Military Cemetery
St Louis, MO
Spring 2016

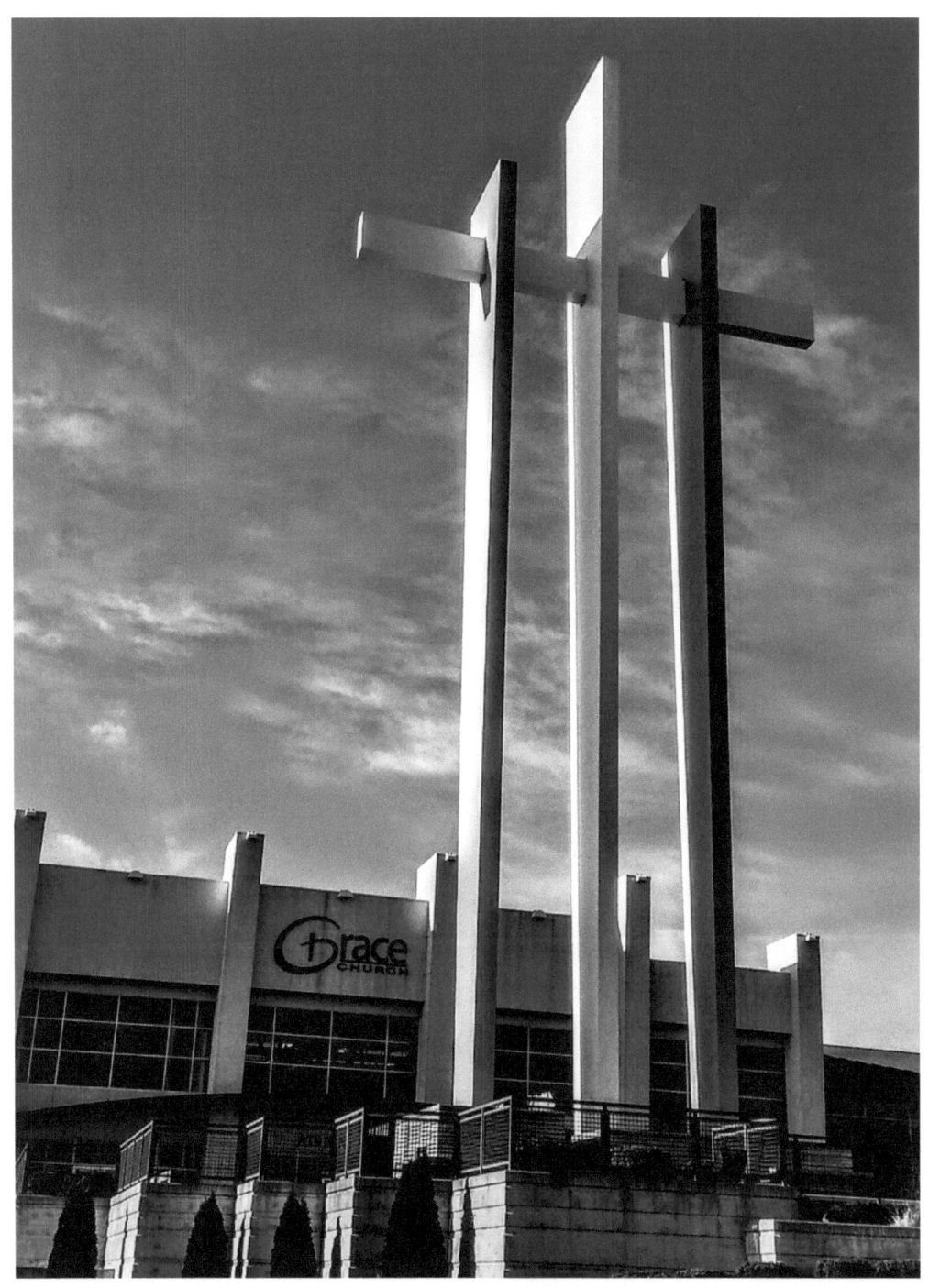

Grace Church
Maryland Heights, MO
Spring 2016

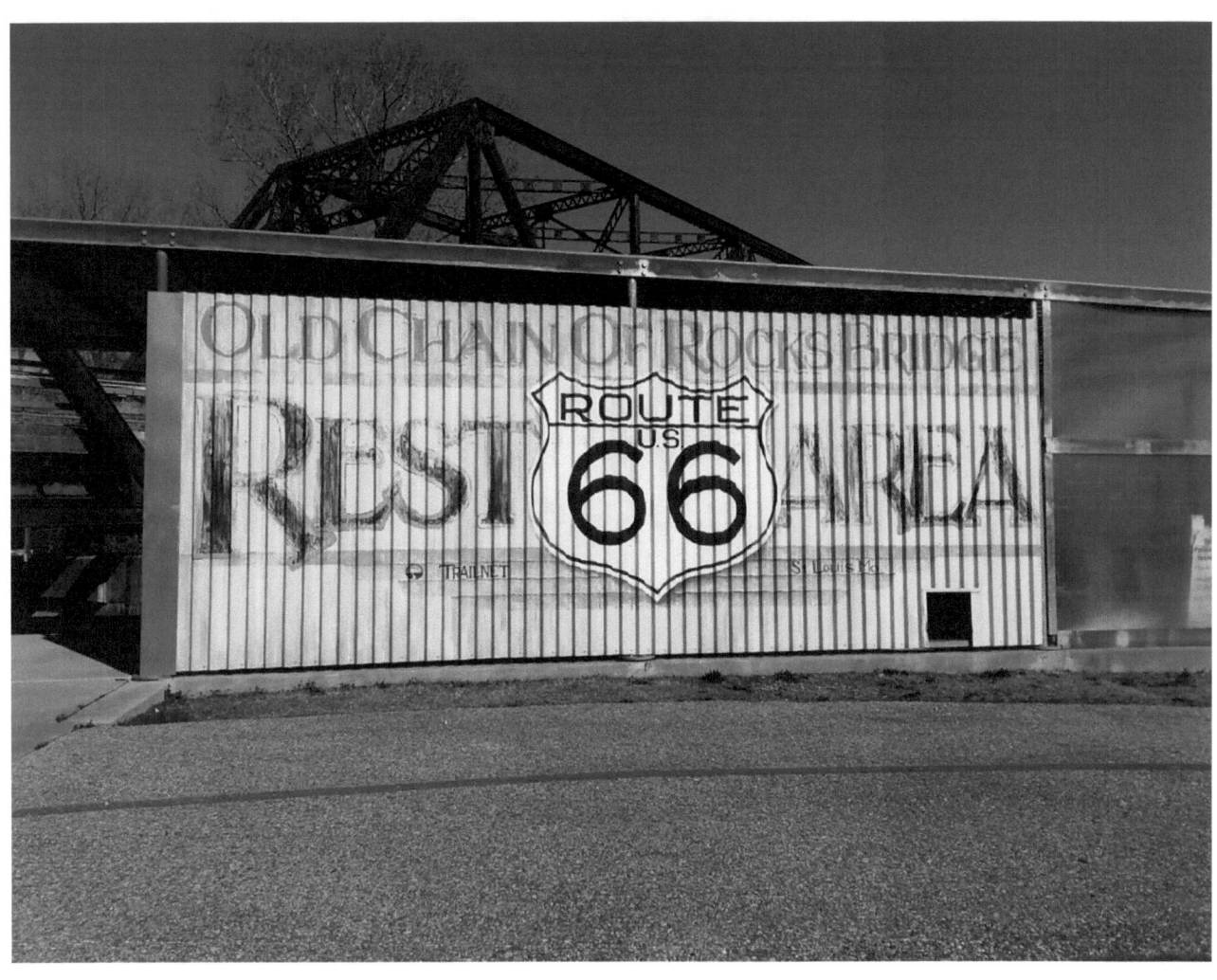

Chain of Rocks Bridge Rest Area
St Louis, MO
Spring 2016

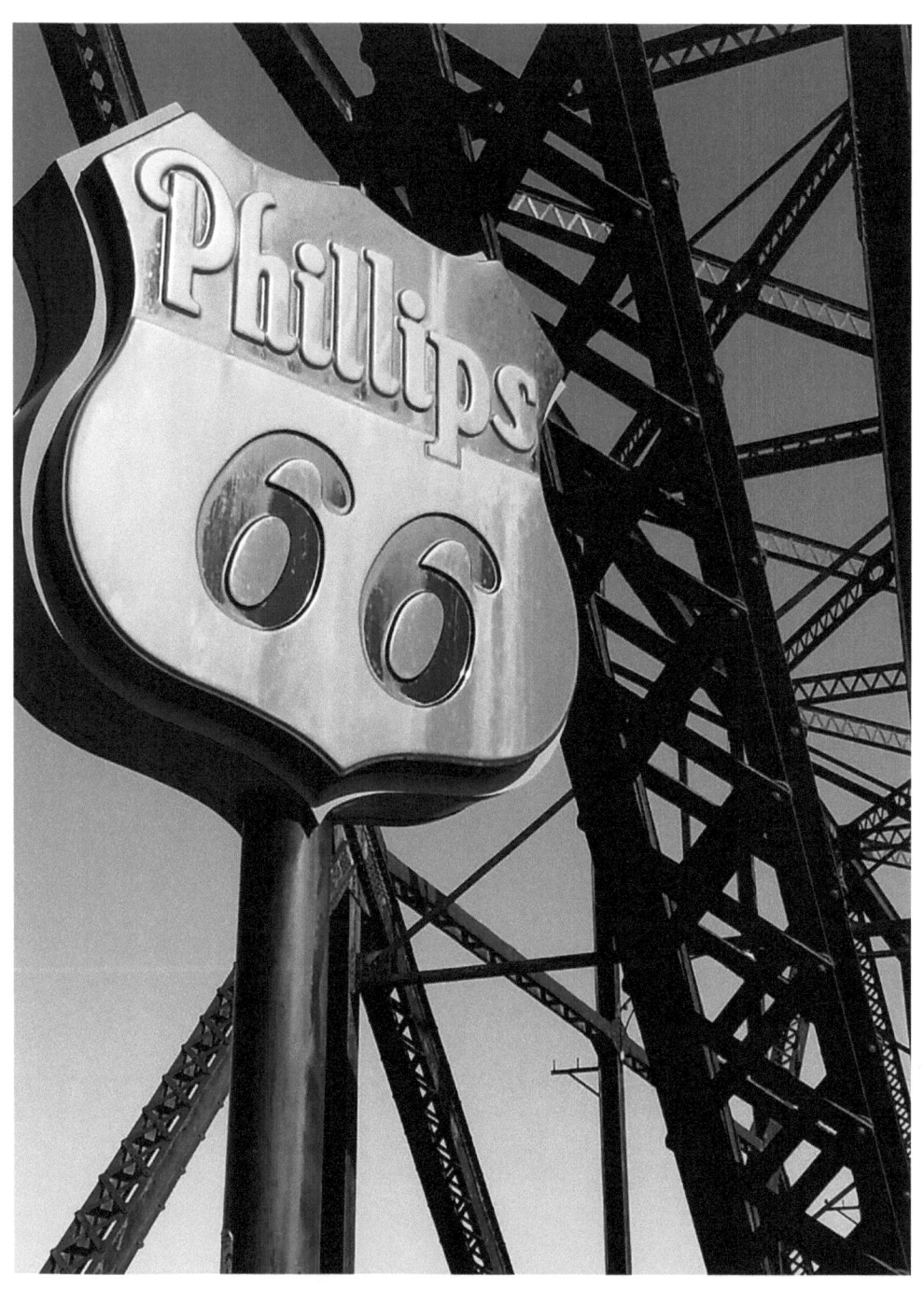

Phillips 66
Chain of Rocks Bridge
St Louis, MO
Spring 2016

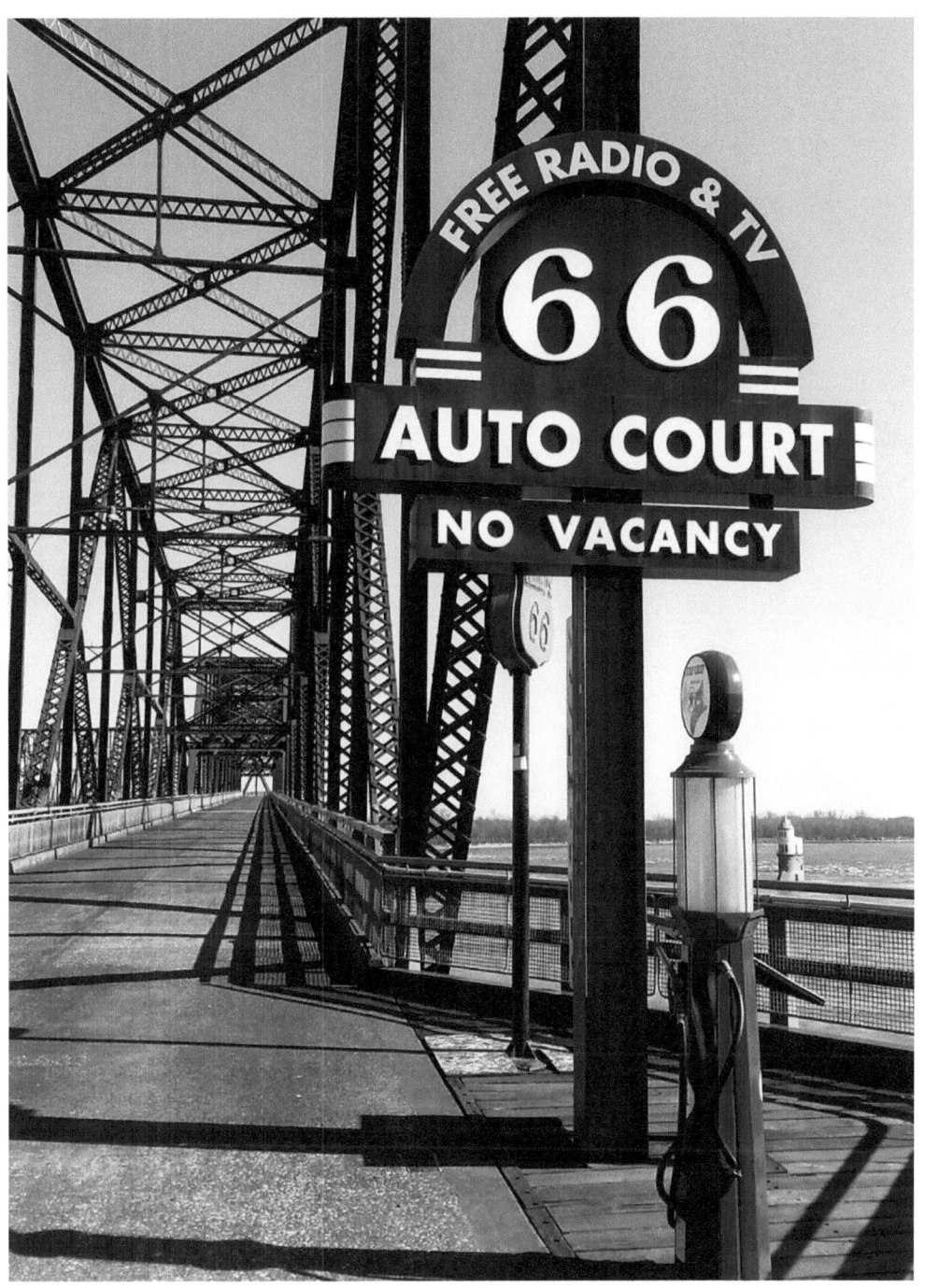

Chain of Rocks Bridge

St Louis, MO
Spring 2016

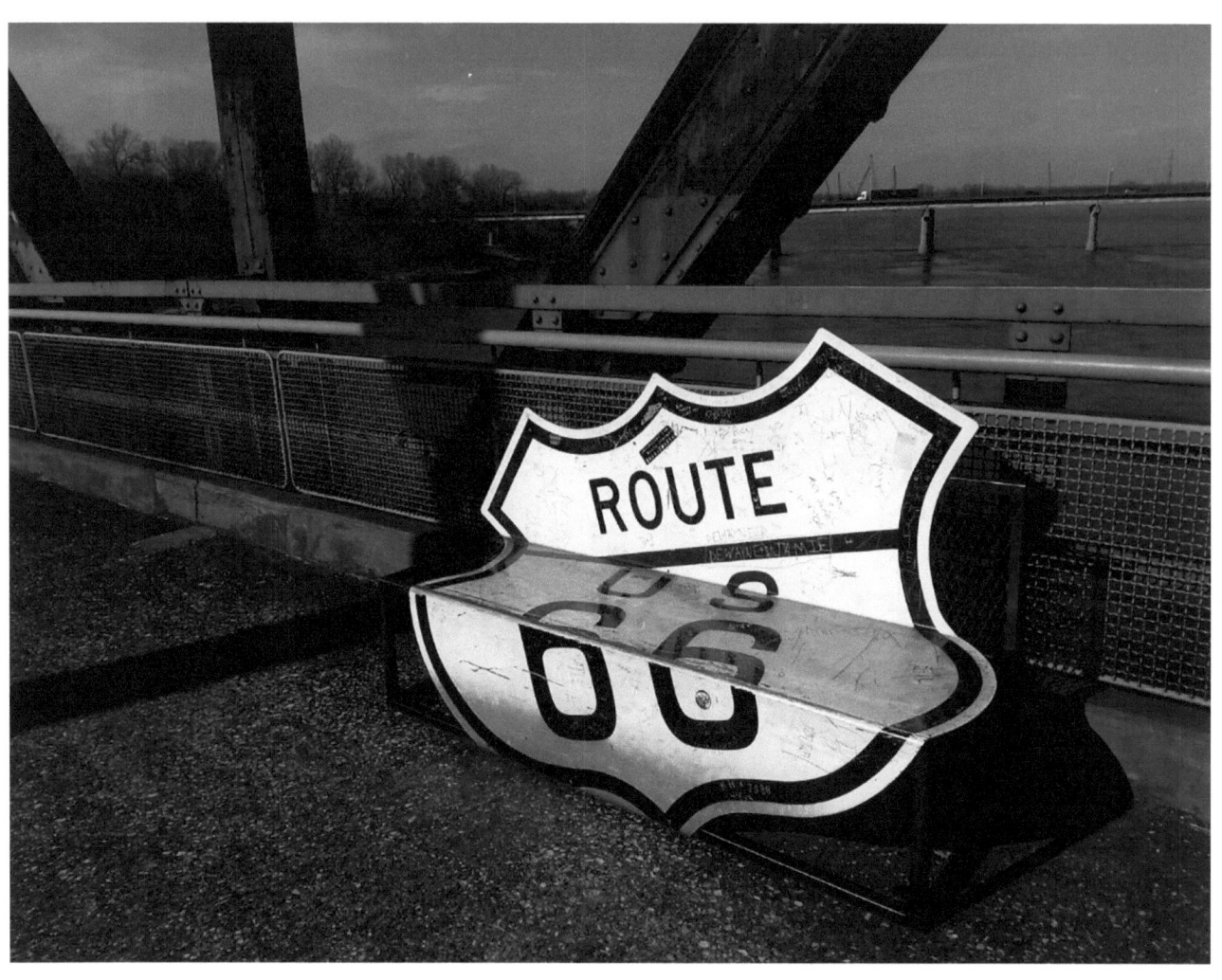

Route 66 Bench
Chain of Rocks Bridge
St Louis, MO
Spring 2016

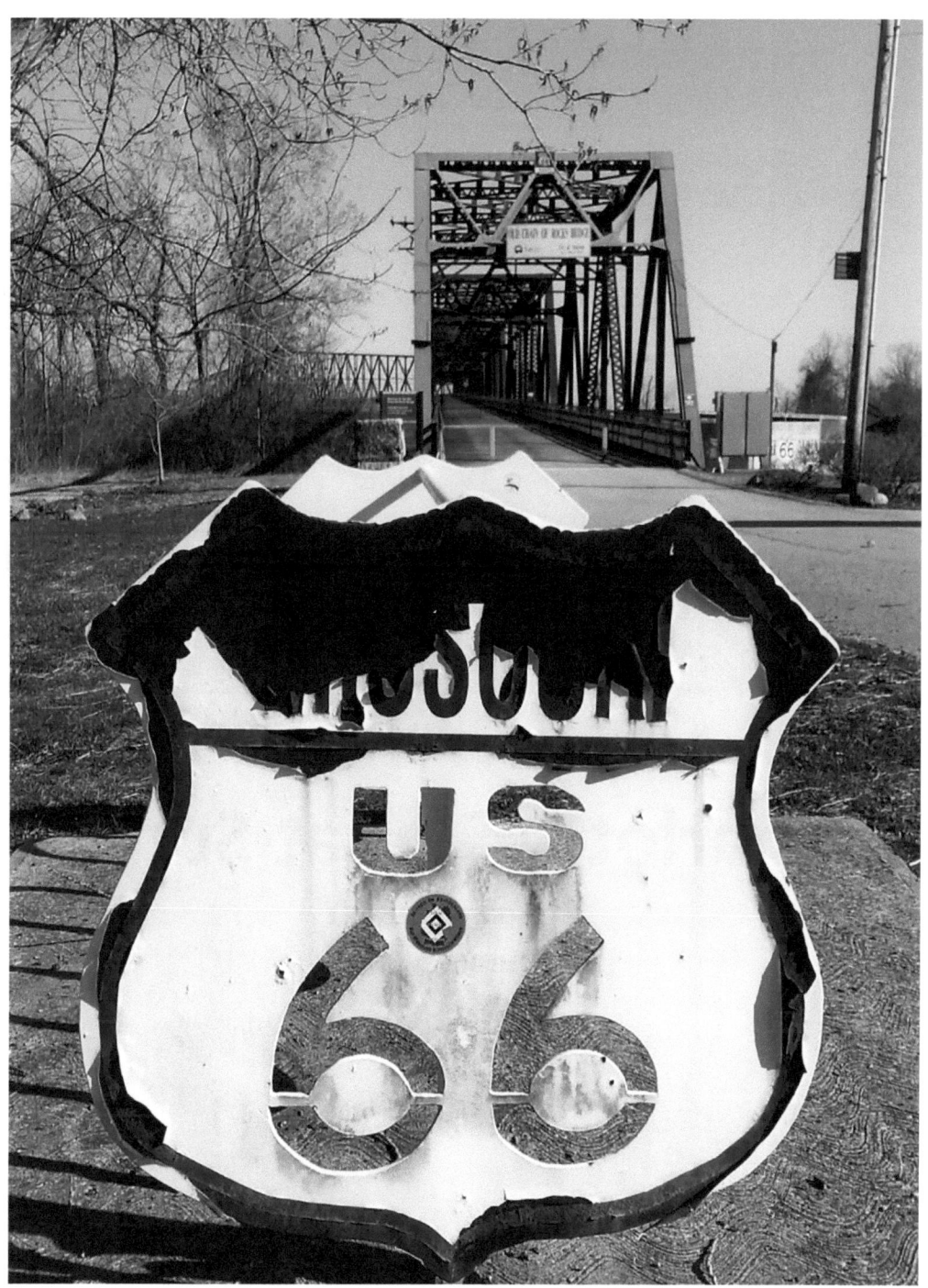

Missouri Route 66
Chain of Rocks Bridge
St Louis, MO
Spring 2016

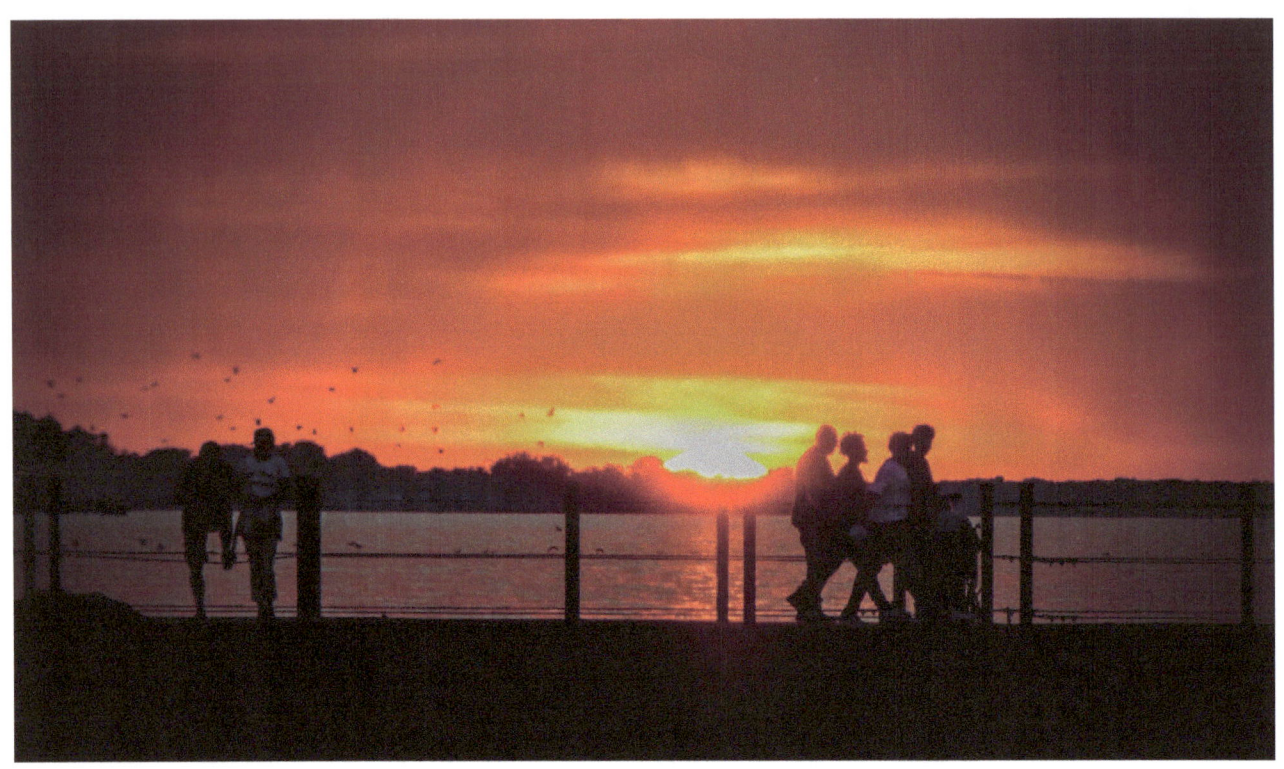

Charlotte Pier at Sunset

Rochester, NY
Summer 2016

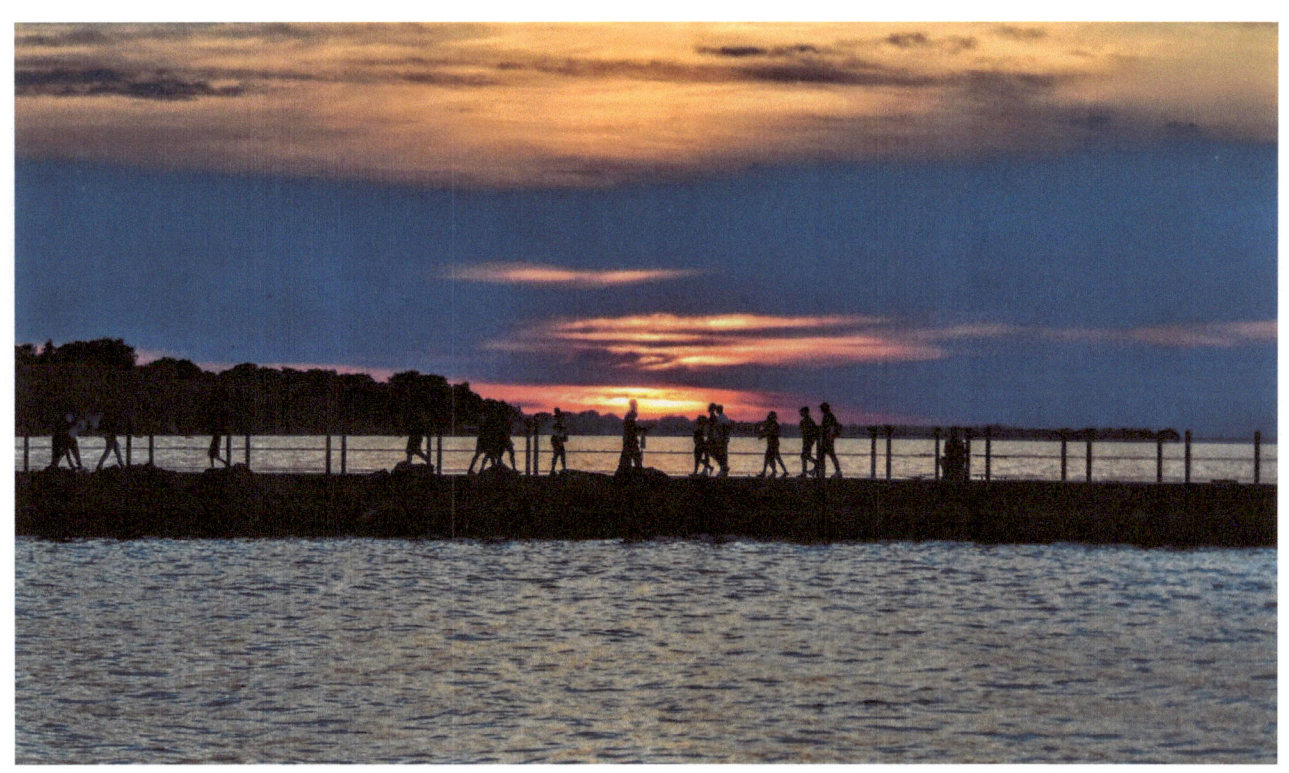

The Pier at Sunset
Charlotte Pier, Rochester, NY
Summer 2016

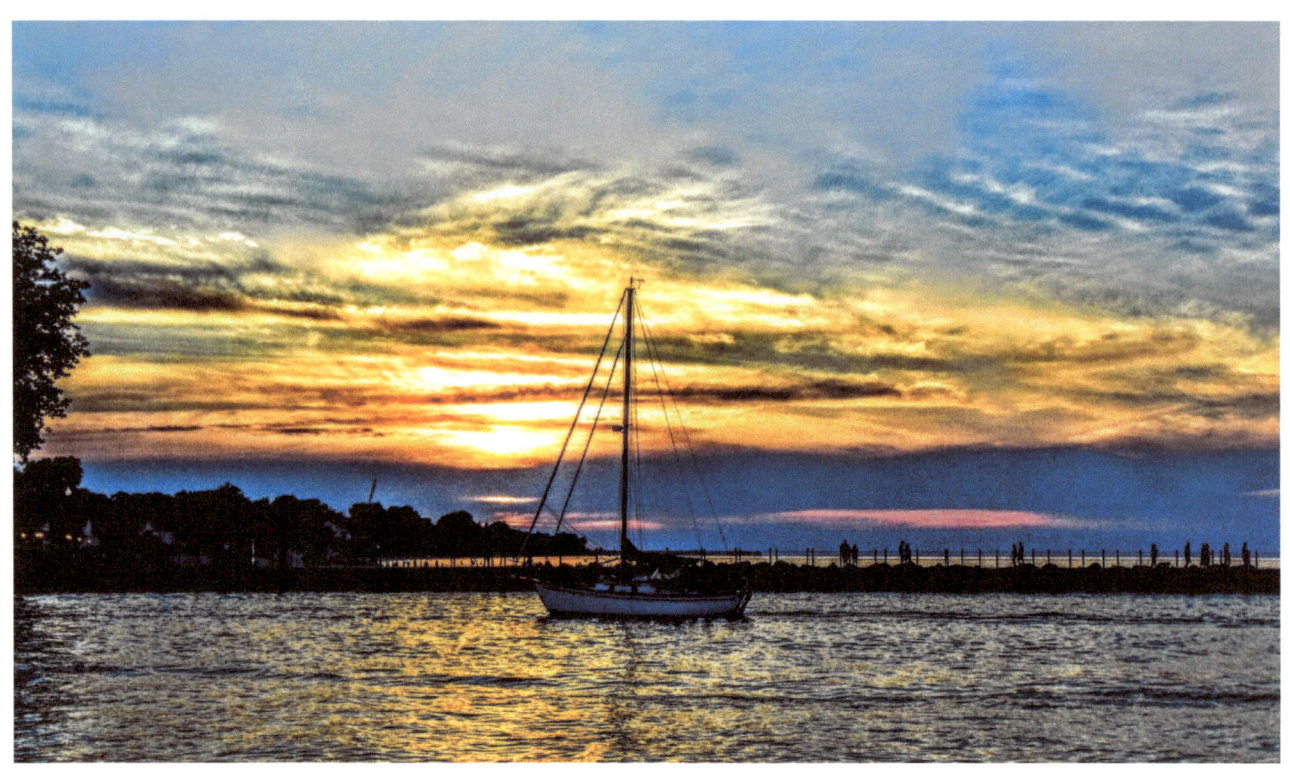

Sunset Cruise
Genesee River, Rochester, NY
Summer 2016

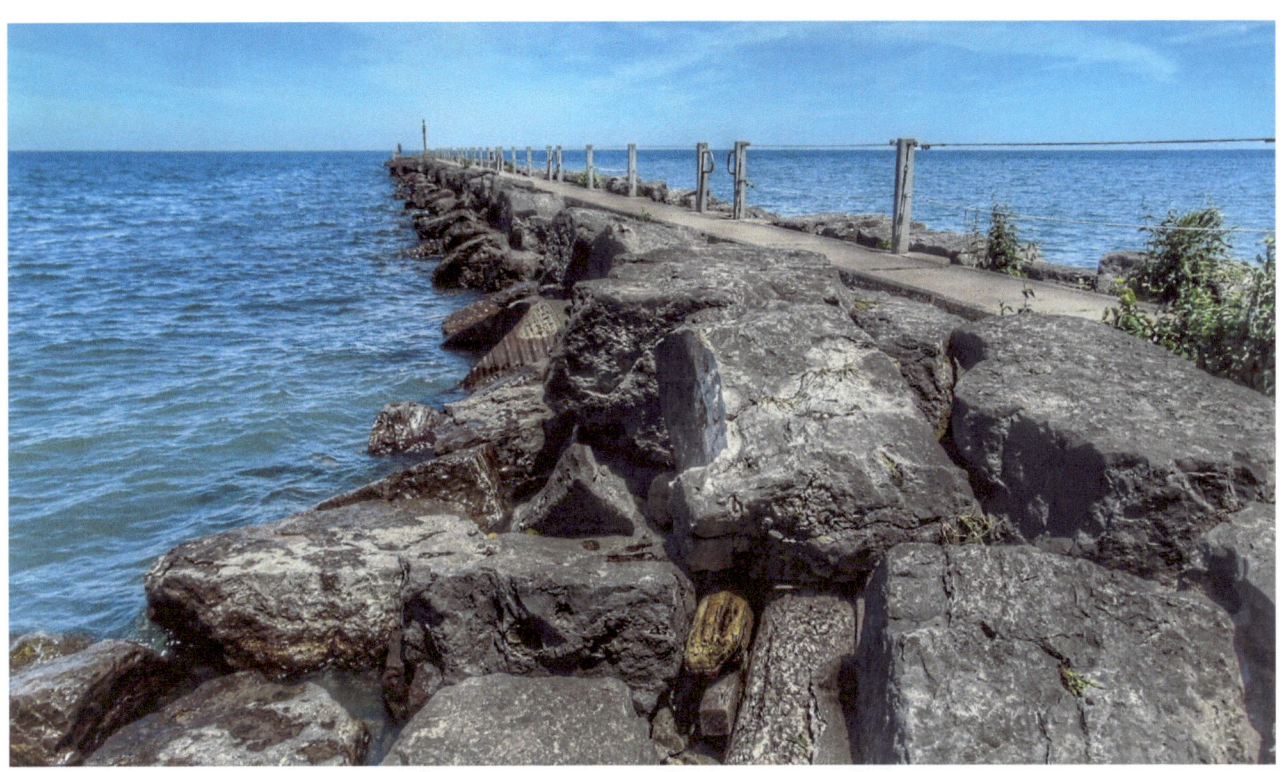

Webster Park Pier

Webster, NY
Spring 2016

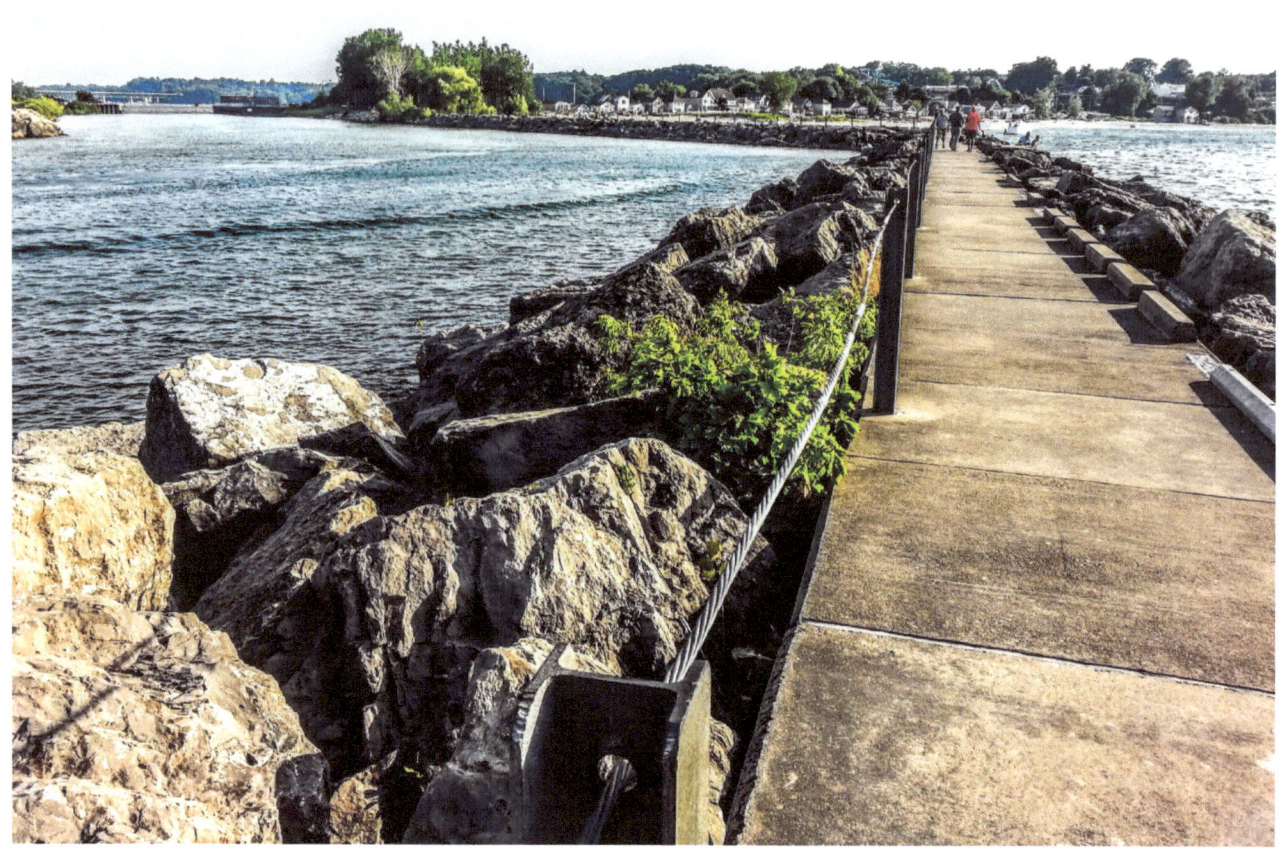

Irondequoit Bay Pier
Irondequoit, NY
Summer 2016

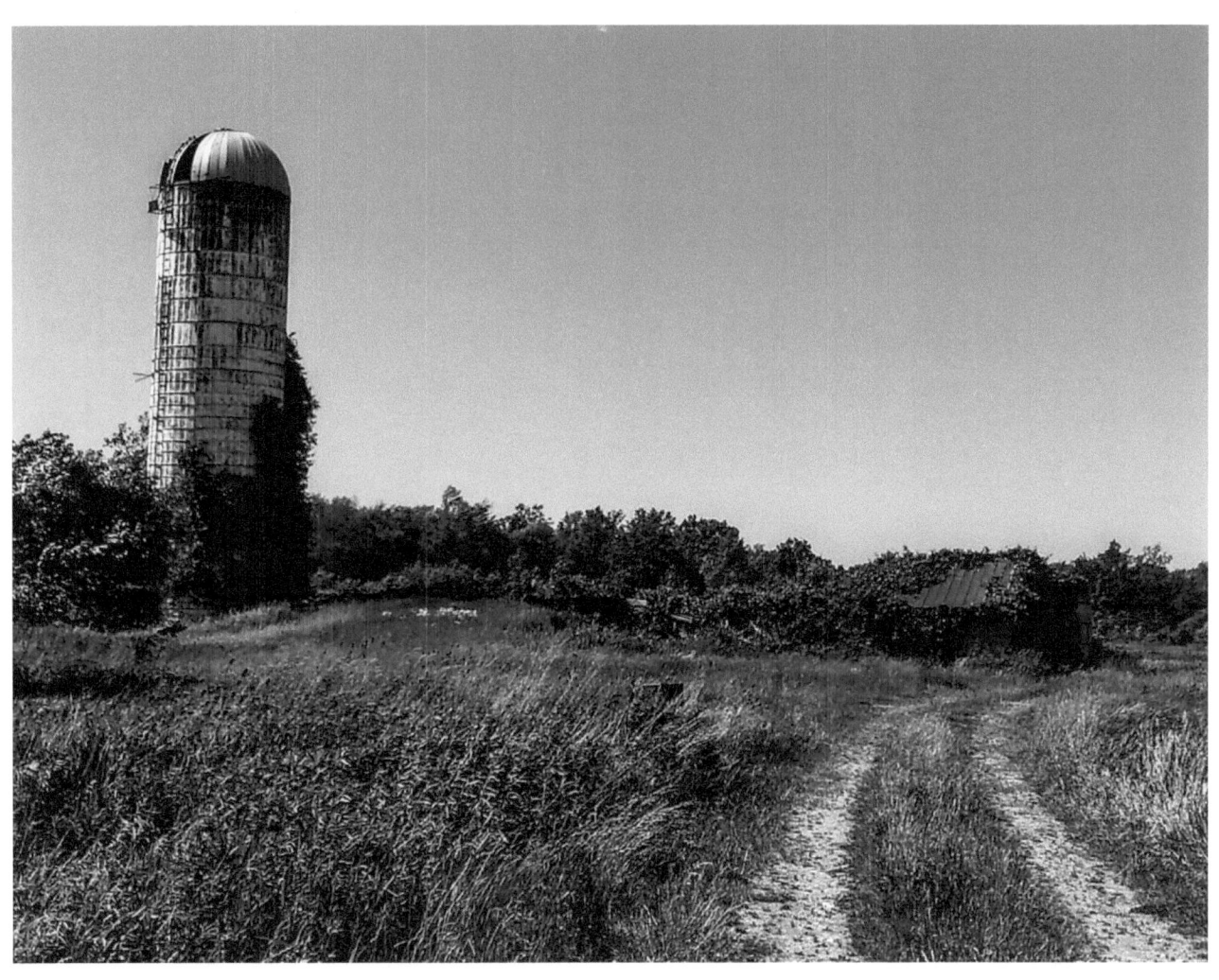

Silo
Churchville, NY
Spring 2016

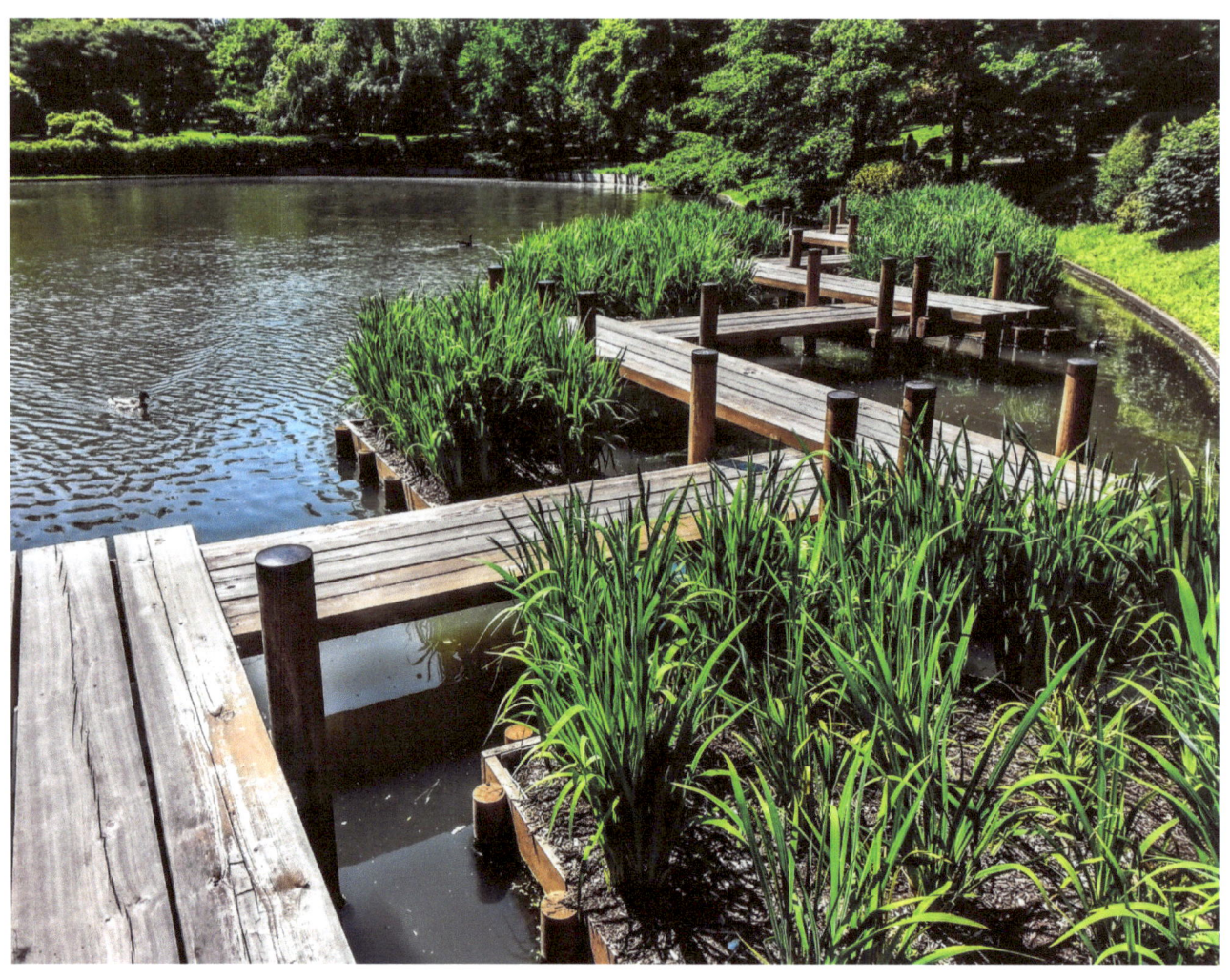

The Walk of Life
Missouri Botanical Gardens
St Louis, MO
Spring 2016

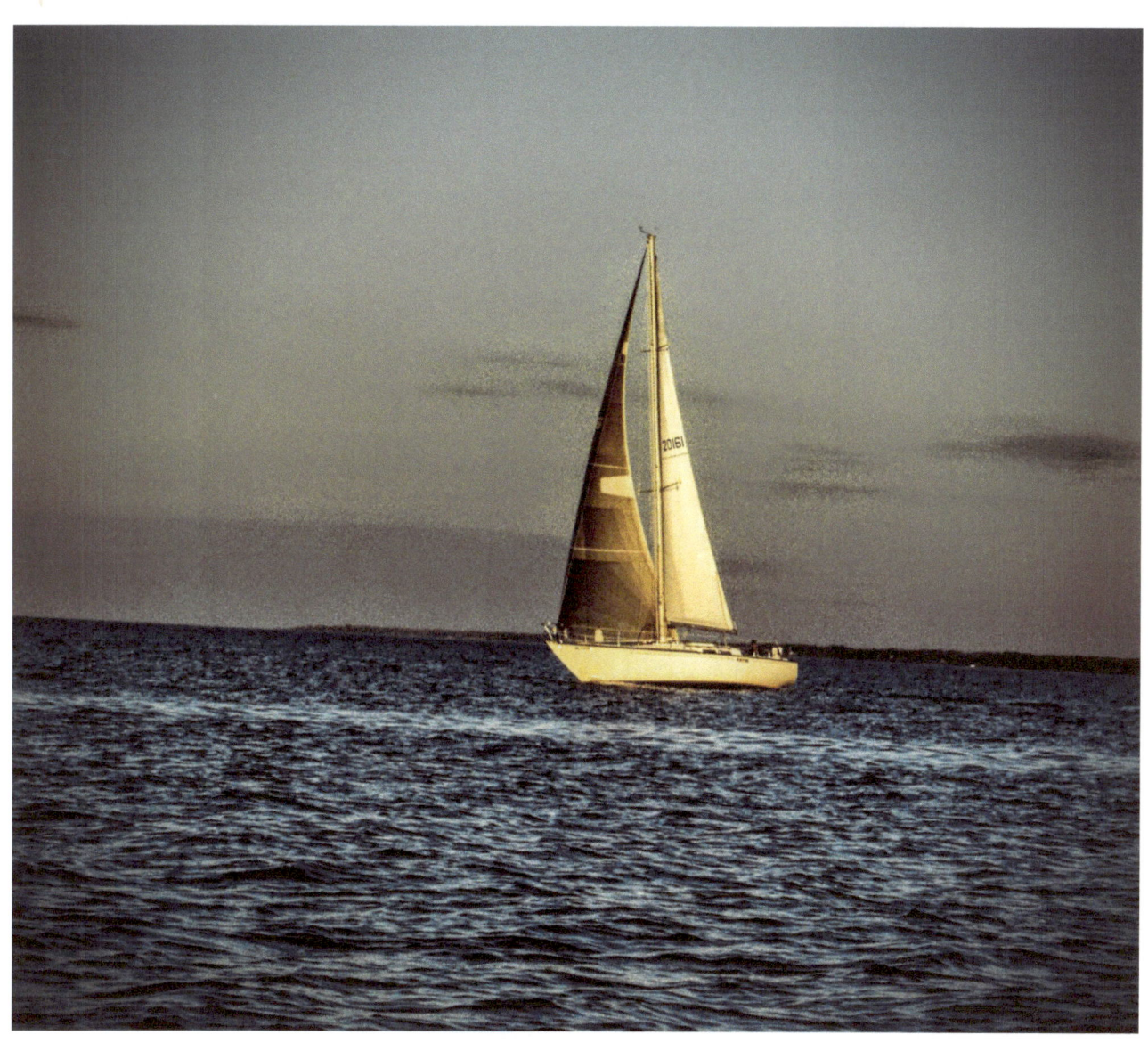

Sailboat

Lake Ontario, NY
Summer 2014

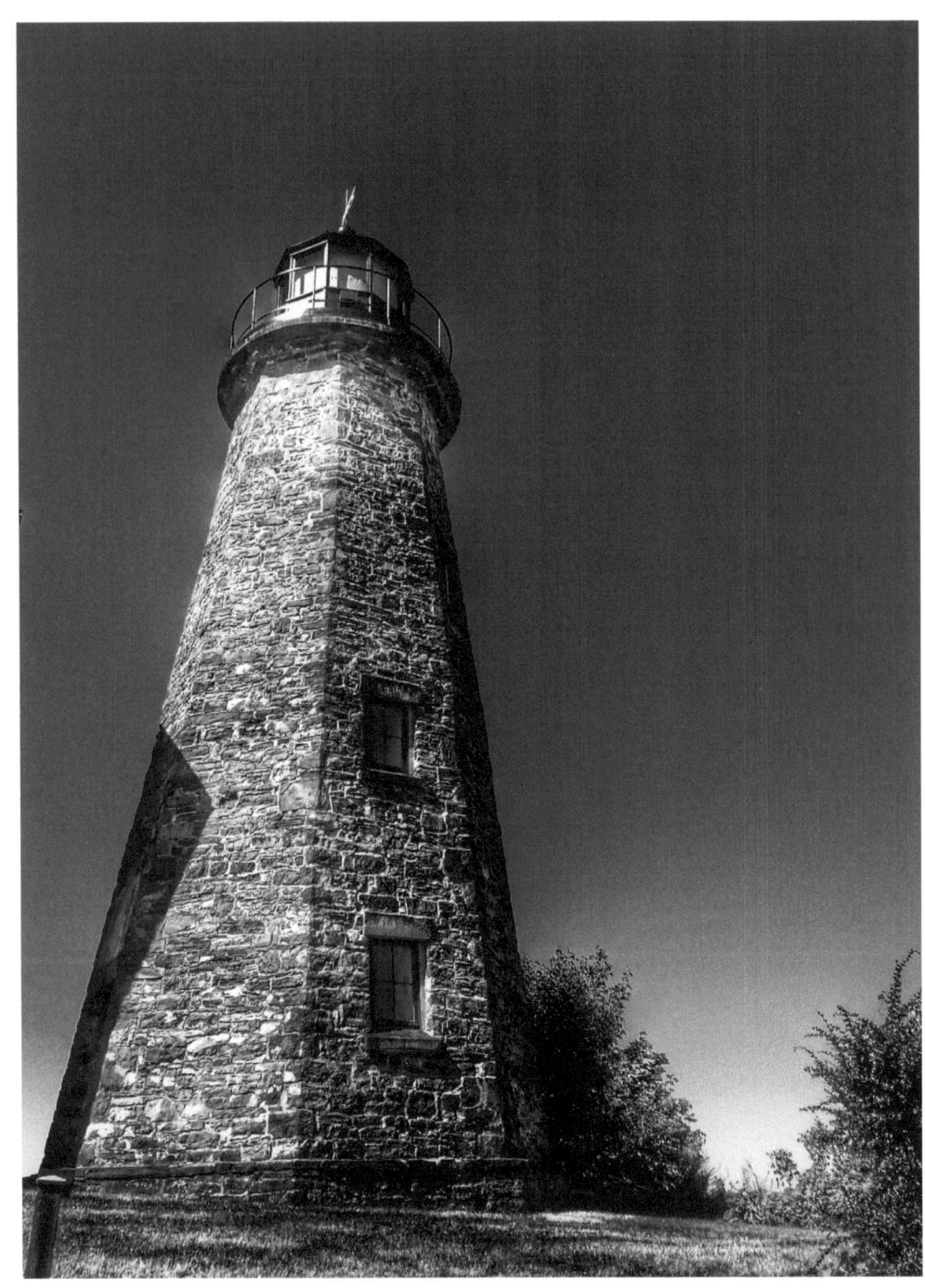

Charlotte Lighthouse
Rochester, NY
Summer 2016

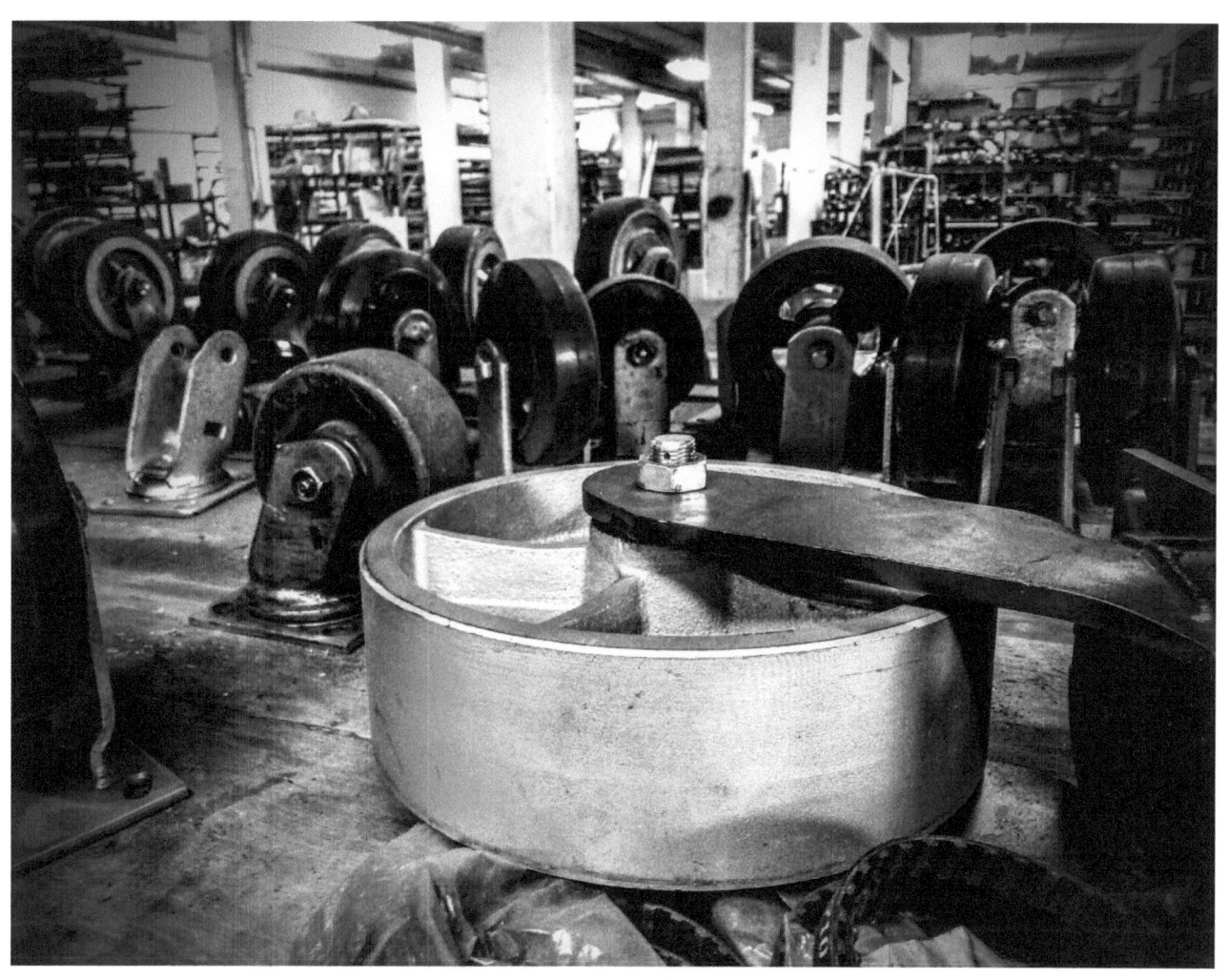

Casters
St Louis, MO
Spring 2016

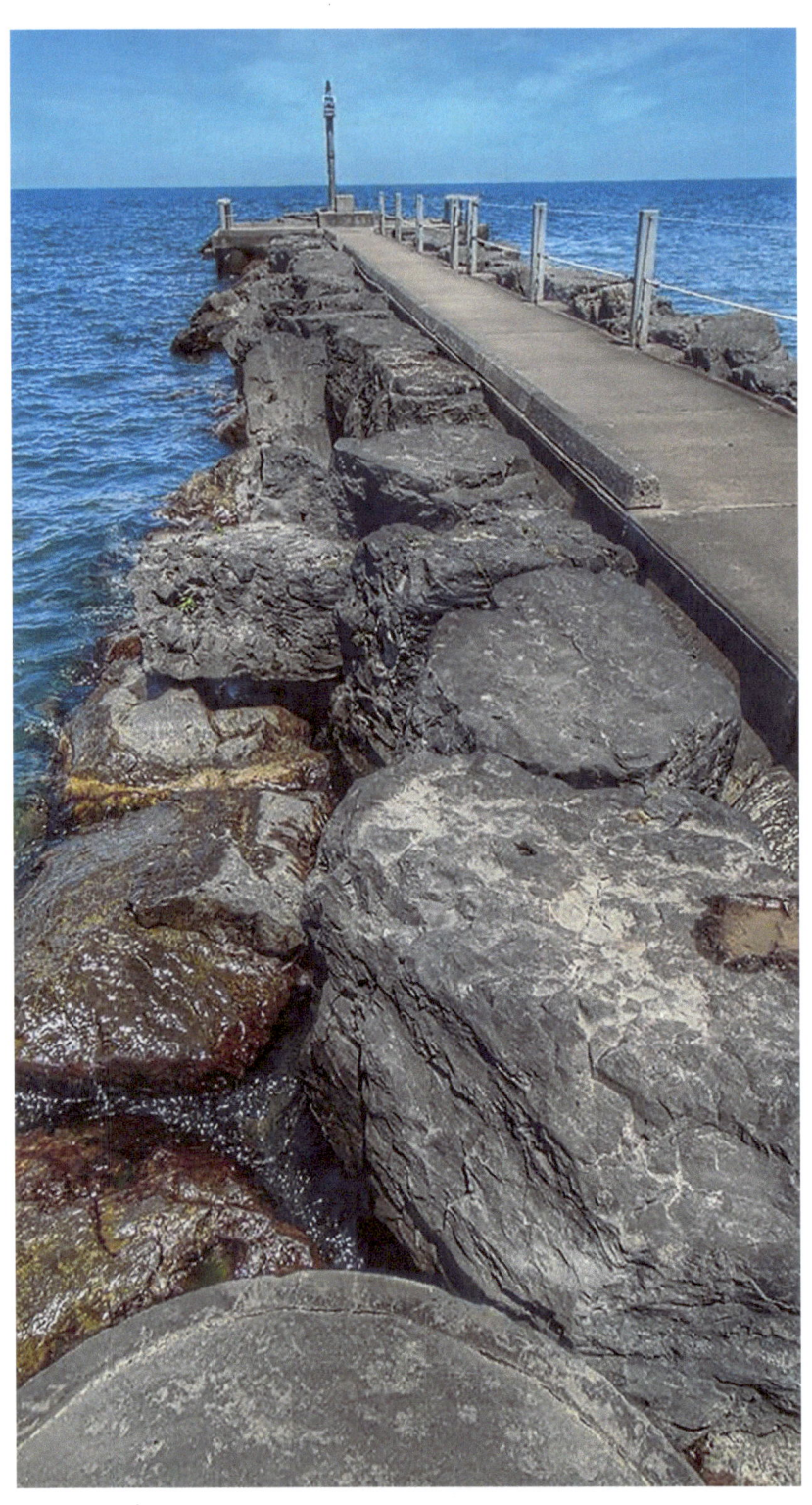

Walking the Pier
Webster, NY
Spring 2016

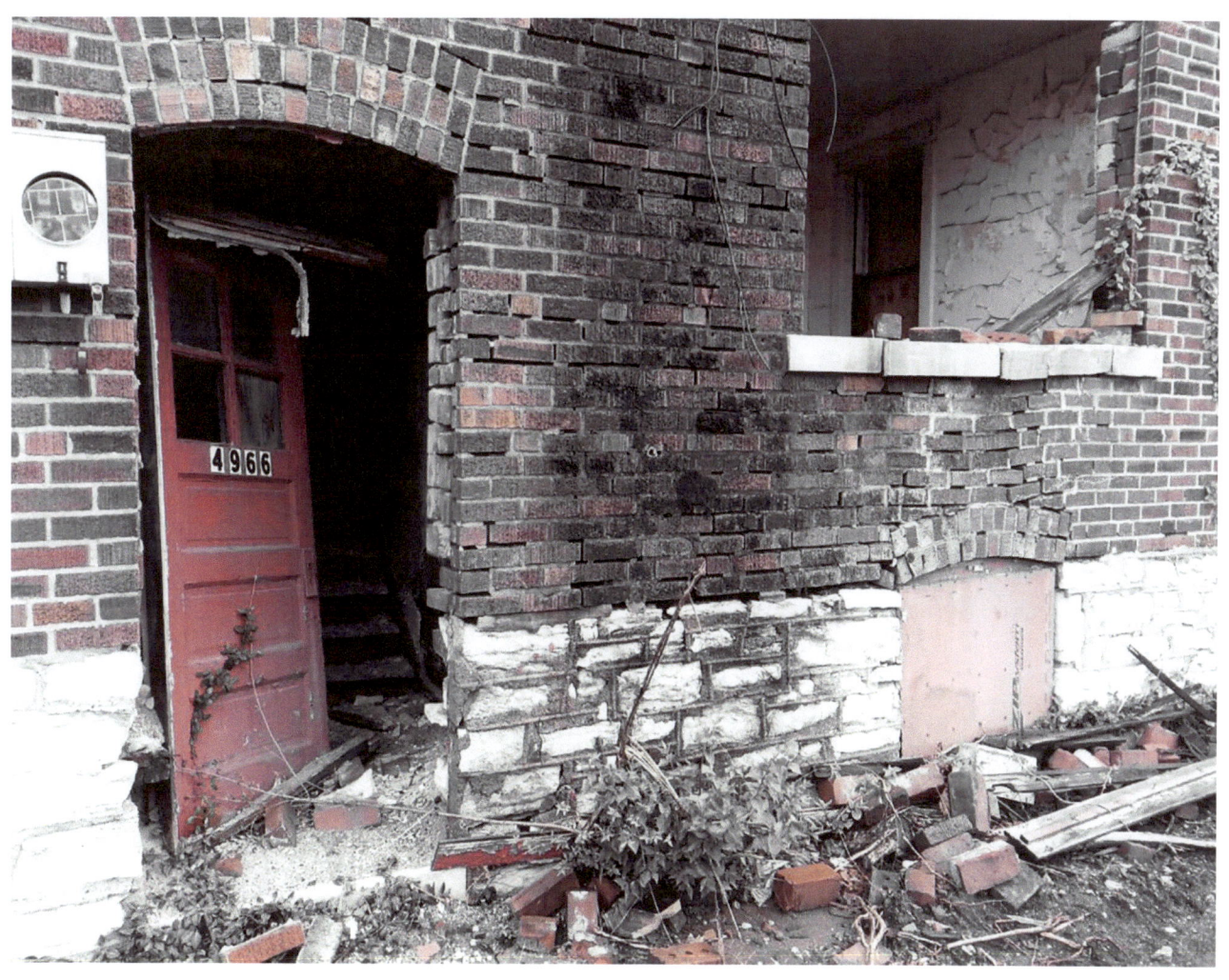

Abandoned
St Louis, MO
Spring 2016

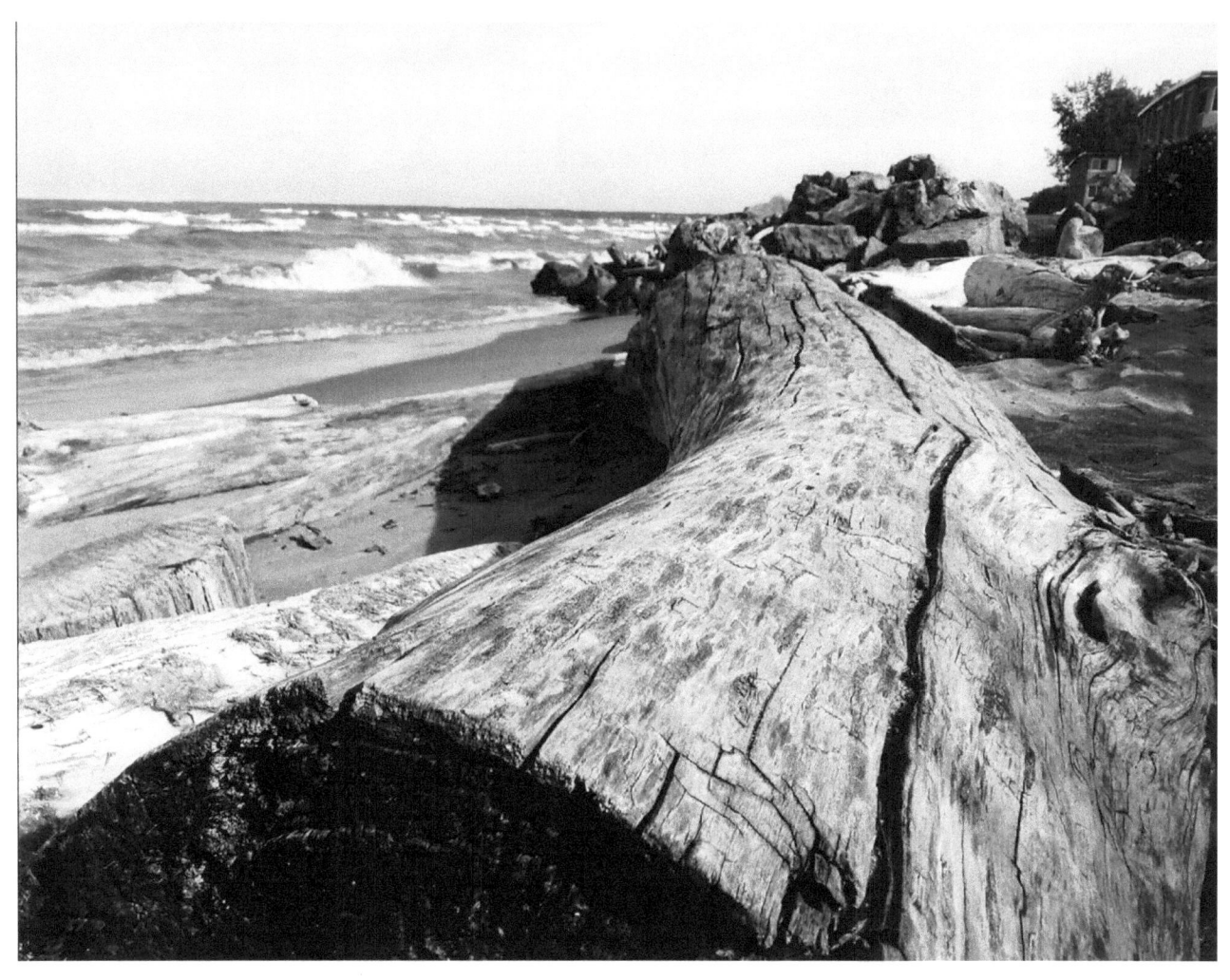

Driftwood
Summerville Beach
Rochester, NY
Summer 2015

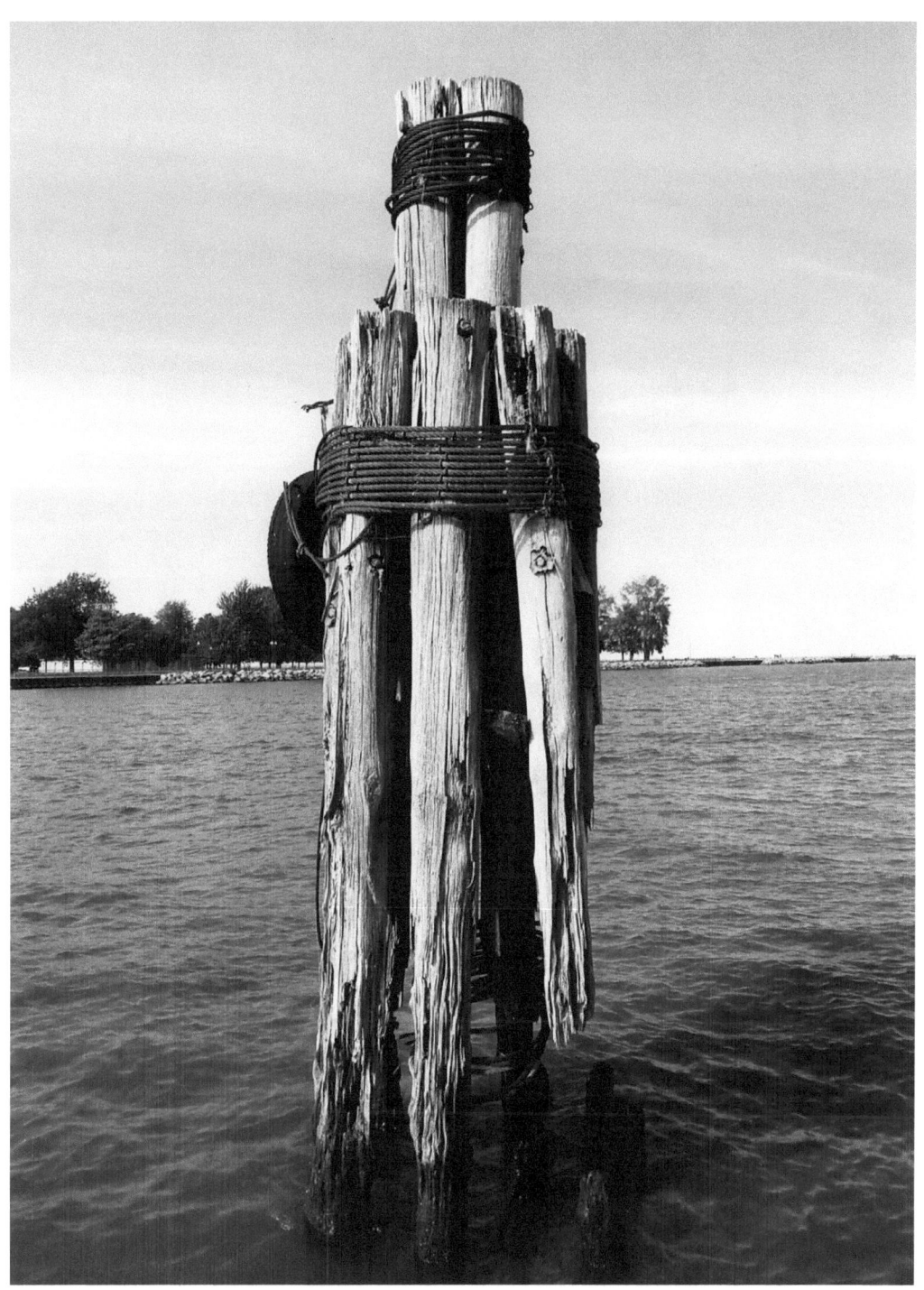

The Guardian
Genesee River
Rochester, NY
Spring 2015

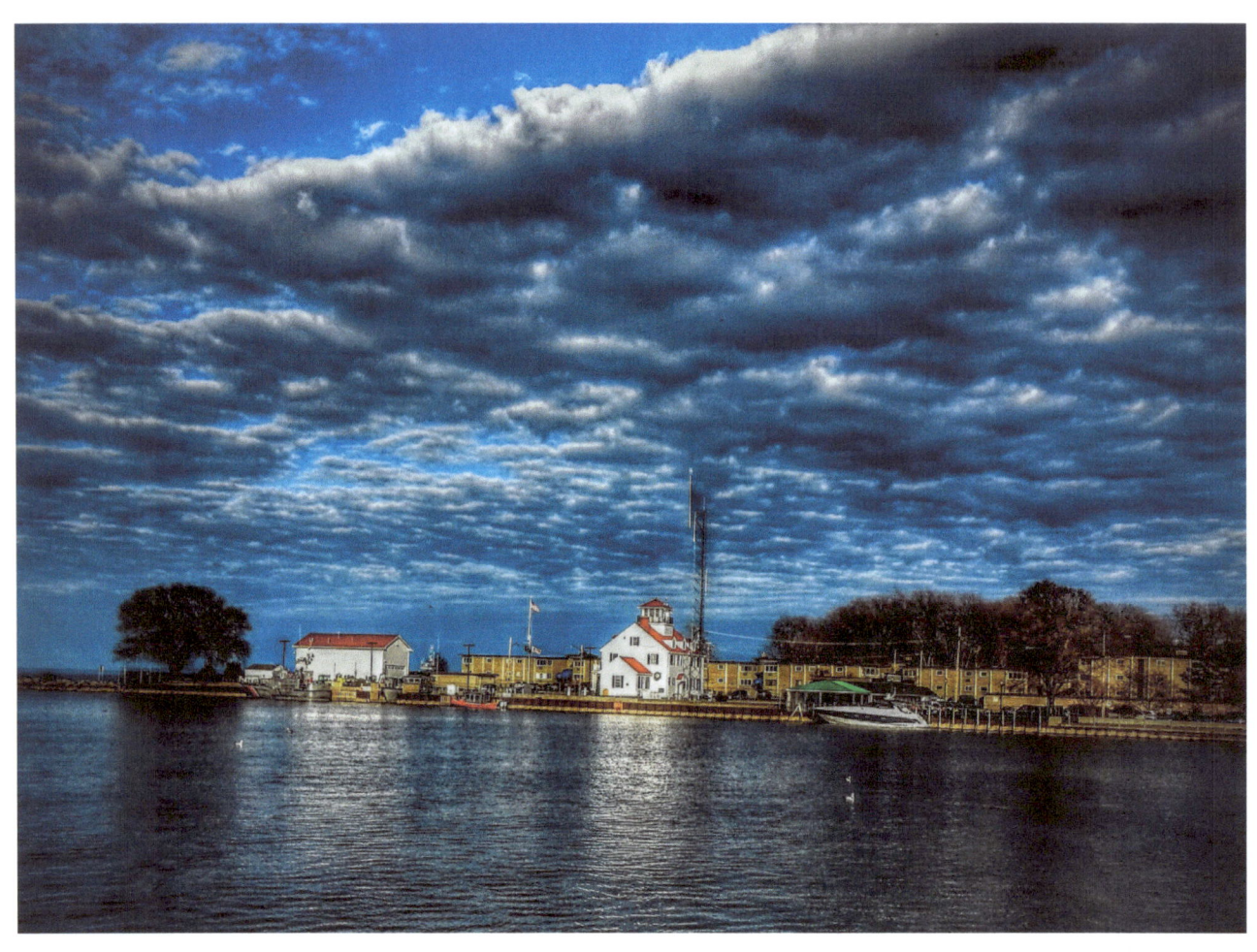

Coast Guard Station
Rochester, NY
Fall 2013

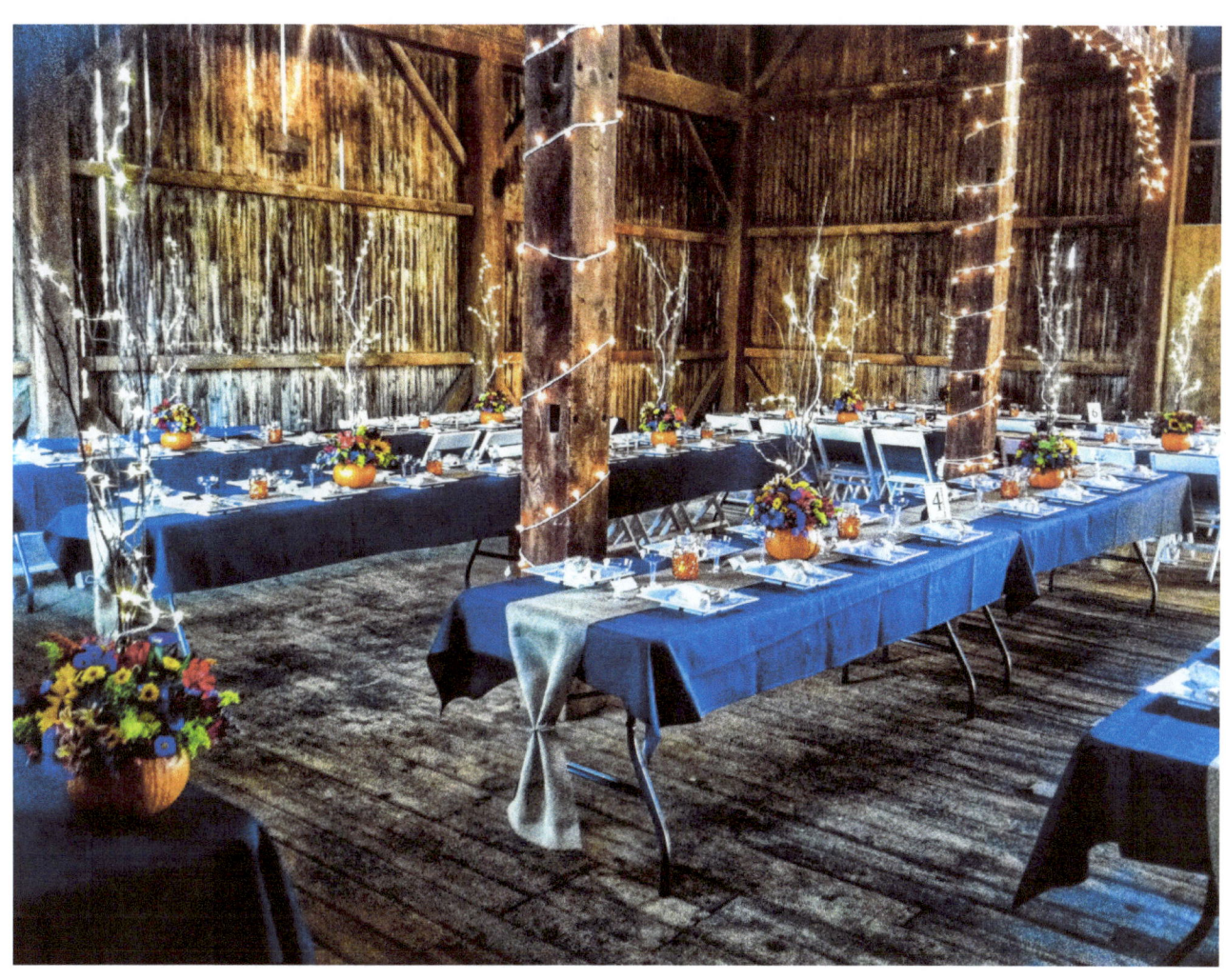

Wedding Reception
The Barn
Rush, NY
Summer 2015